INTRODUCTION TO Drawing

Ronald Pearsall

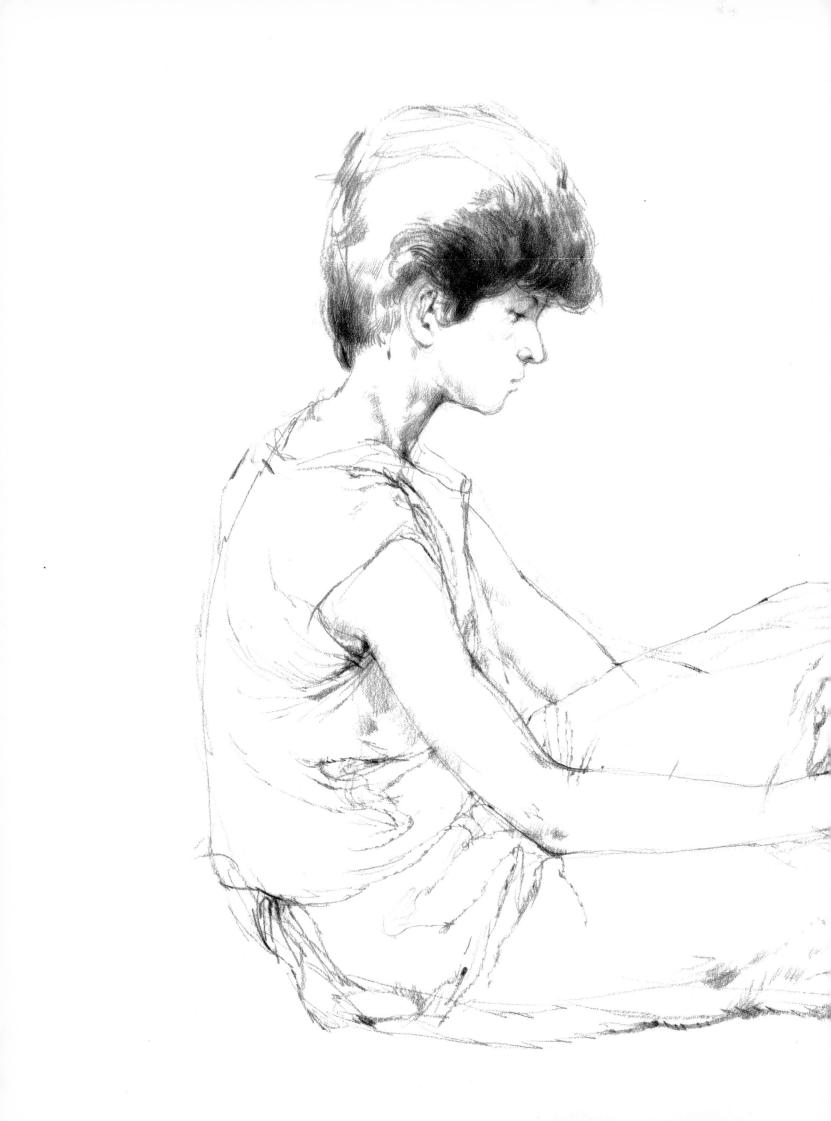

INTRODUCTION TO Drawing

Ronald Pearsall

First published in the United States of America in 1990 by the Mallard Press An imprint of BDD Promotional Book Company, Inc. 666 Fifth Avenue New York, N.Y. 10103

Copyright © 1990 Brian Trodd Publishing House Limited

All rights reserved. No part of this publication may be reproduced, stored in a retrieval system, or transmitted, in any form or by any means, electronic, mechanical, photocopying, recording or otherwise, without permission in writing from the publisher.

ISBN 0-792-45118-X

Printed in Portugal

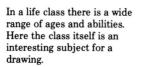

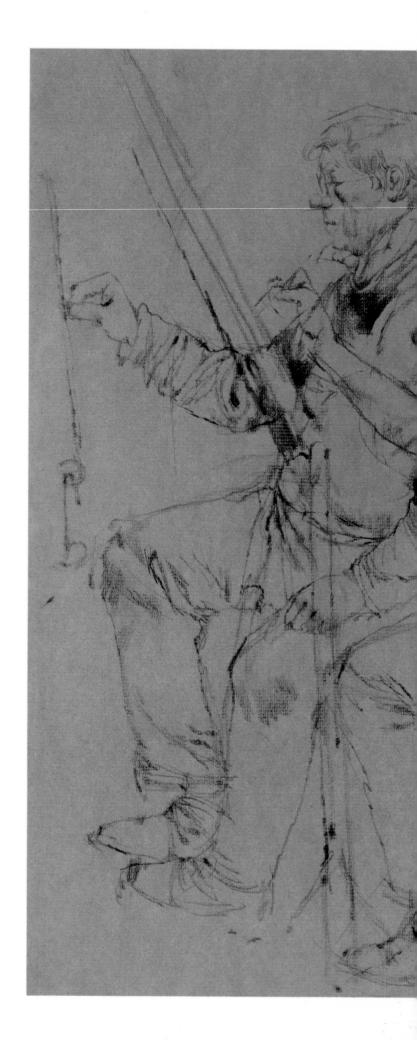

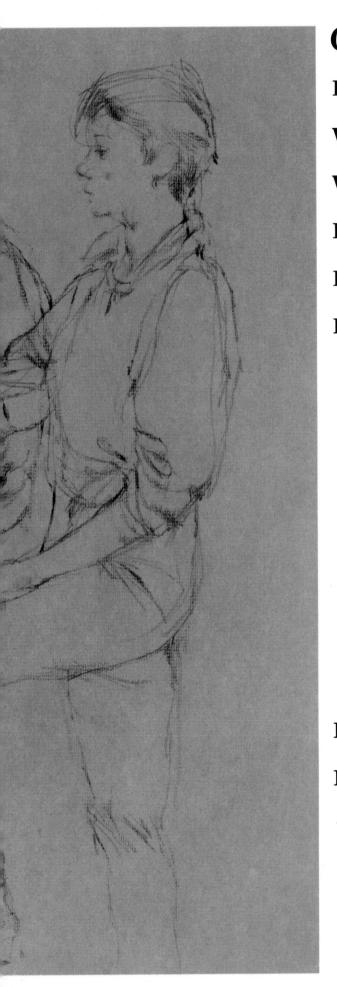

CONTENTS

Introduction	11
What is a drawing?	12
What materials are needed?	12
Is drawing difficult?	17
How do I start?	23
Having started the drawing, how do I carry on?	36
Figure drawing	38
Portrait drawing	47
Animal drawing	57
Landscape	63
Townscape	69
Still life	72
Seascape	75
Picture making	79
Framing	92

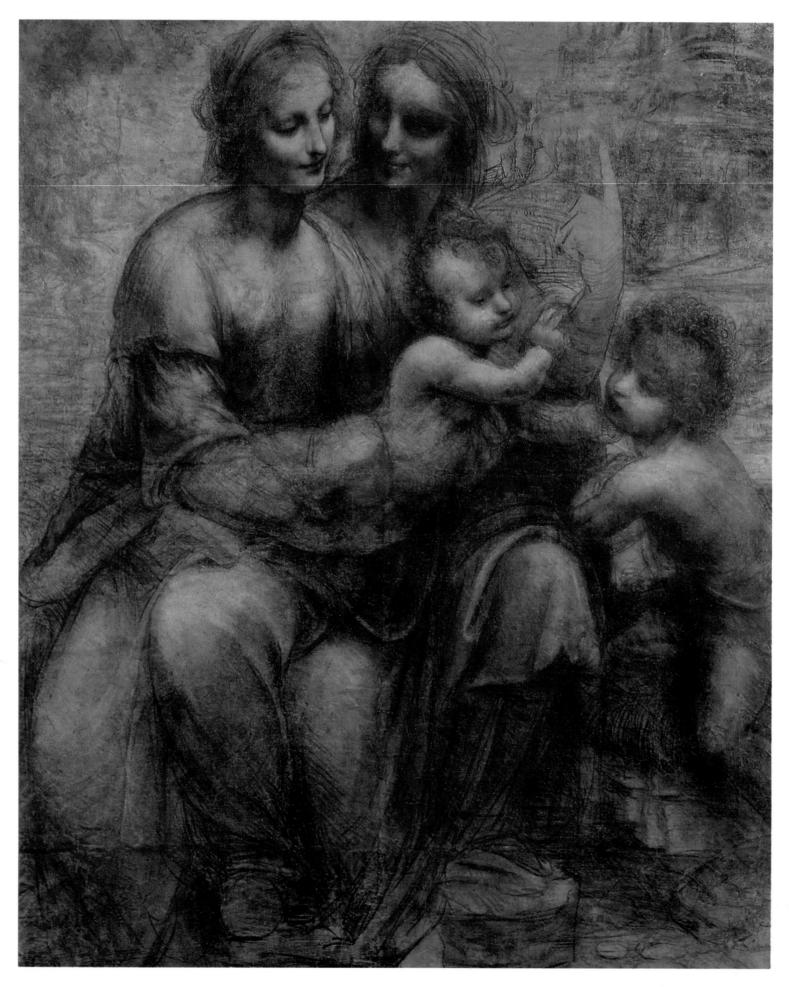

Introduction

Being able to draw something in front of you, whether it is a landscape, a figure, or a portrait, is one of the great pleasures of life. There is a challenge, that of representing three dimensions in two, but it is a challenge that should be taken up as it is a skill that can be easily acquired. Drawing is much easier than playing the piano; and, as with musicians, there are naturals. There are men and women – and children – who can look at an object and depict it as it is, not as they think it is, without thinking twice about it. And there are others who have to work at it.

If you can call it work! For the accent of this book is on fun. All you need to start is some paper and a pencil, but one of the delights of drawing is that you can expand your repertoire. You may move from pencil into charcoal, or into pastels or paints; and, if you do, your knowledge of drawing will prove invaluable. It is all very well splashing about with a paint brush, but you have to know what you are doing, even if you are dealing with masses and shapes and not lines and shading.

Drawing offers something for everybody. You may like to go into the countryside and sketch quietly by yourself, or you may prefer townscapes. If you are nervous, and don't want strangers looking over your shoulder, draw in the comfort of your car. Or you may like to join a sketching club. There are more of them than you may imagine. For there are a lot of you out there!

The Virgin and Child with St Anne and St John the Baptist by Leonardo da Vinci. This cartoon is perhaps the most beautiful drawing that has ever been made. It is the model for every would-be draughtsman.

WHAT IS A DRAWING?

The dictionary defines drawing as the art of representing objects or forms by lines drawn, shading, and other means – that is a picture in lines. There are actually at least four types of drawing: trying to represent something in front of the artist; trying to depict something from memory; copying something in another medium; and creating something entirely from imagination. Drawing is usually carried out with a pencil or a pen, charcoal or a crayon, but it can also be done with a pointed instrument on metal (etching) or stone (lithography) or with something soft and flexible such as a brush.

WHAT MATERIALS ARE NEEDED?

Pencils range from the very hard (designated by H) to the very soft and black (B). There are 10 grades between 6B and 4H, the average office pencil being HB. Pencil lead is a mixture of clay and graphite, and the greater the proportion of graphite the softer and blacker the pencil mark. It is useful to have several grades of pencil for use in one drawing. Hard pencils can be sharpened with a pencil-sharpener, but 2B and upwards need to be sharpened with a knife. The point can be tapered or given a chisel edge (very useful for shading). Pencils should always be sharpened at the opposite end to that which shows the degree of hardness or softness; otherwise HB, 2B or 2H or whatever will be lost. Small pieces of sandpaper will keep the pencil point exactly as you want it; art shops sell these in little blocks. There is also an excellent range of coloured pencils in a multitude of shades, but there is little variety of hardness and softness, save between the products of the various manufacturers. These should not be confused with pastel pencils.

Pens also offer an immense range. Drawingpen nibs are usually sold in sets of a dozen or so, and nibs themselves vary in size from mapping-pen nibs to those designed for doing posters. The larger nibs often come fitted with a kind of a tray, called a reservoir, so that there is a ready flow of ink. Lettering pens can be very useful, and so can the so-called calligraphic pens. Some people refer to pen-nibs as pens, which can be very confusing. For those who find it tiresome to dip the pen in the ink constantly there are of course fountain pens, especially those with interchangeable nib units.

Just as the steel nib replaced the quill, so today the steel-nibbed pen has been partly superseded by the Rapidograph, which has a range of nibs from 0.1 (very fine) to 0.8 (broad). The virtue of a constant flow of ink and a consistent line compensates for a lack of flexibility in the nib itself. A drawn line cannot be varied by pressing down on the point, as with the oldfashioned steel nib. When using pen and ink always have a variety of pens and nibs available so that you can change from one to another if the need arises. As pen nibs are now so little used other than in art, it is worth mentioning that they are vulnerable to ill-usage and have a limited life span. If the points 'cross over' reject them immediately; there is little profit in trying to restore them. A Gillott 303 nib is flexible and useful for both narrow and broad strokes. A 'J' nib is the smallest lettering pen, giving a hard line, and is very handy for flat patterns and hatching. It is a good idea to have a small round sable brush near at hand to use with the pen and ink. Although the brush can be used with full-strength ink, very pleasant effects can be created with diluted ink. An old toothbrush is also a handy accessory for spattering ink, if you rub a fingertip (or, if this is too messy, a piece of wood or an old ruler) down the bristles. Spattering ink onto watercolour can create amazing textures and effects. Rapidographs with a very fine nib do have a tendency to get clogged up, and the nibs need a good deal of care. Modern Rapidograph pens are cartridgefilled, a great improvement on manual filling from a small plastic bottle.

Inks come in numerous colours, though black remains the most popular. Indian ink is probably the best kind of ink to use. Ink can be waterproof and water-soluble, and coloured inks can be used to great effect in combination with watercolour, especially on a moist surface where the colours can run into each other. Nothing can be knocked over quite so easily as an ink bottle, so keep it on a saucer. A small flat cardboard box, of the kind used for cigarettes or chocolates, with a hole made in the lid is better still. The card at the edges of the hole can be pushed up to hold the ink bottle tighter.

Papers Anything which will take a pen or pencil line can be used for drawing. Artists of the past showed a particular fondness for the backs of old envelopes. The traditional artschool paper is cartridge paper, sold in various weights, and best bought in sheet form and cut in two or four. Decent cartridge paper takes watercolour well, and is a good substitute for watercolour paper as well as being less ex-

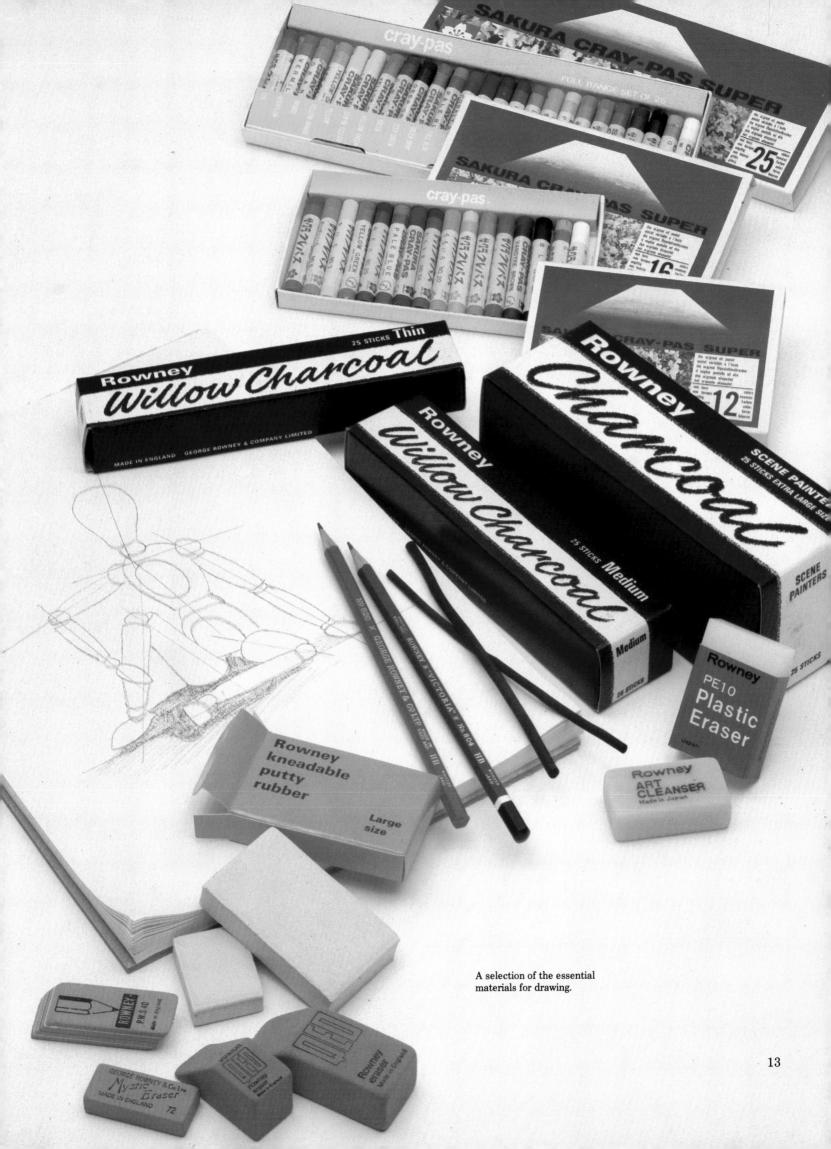

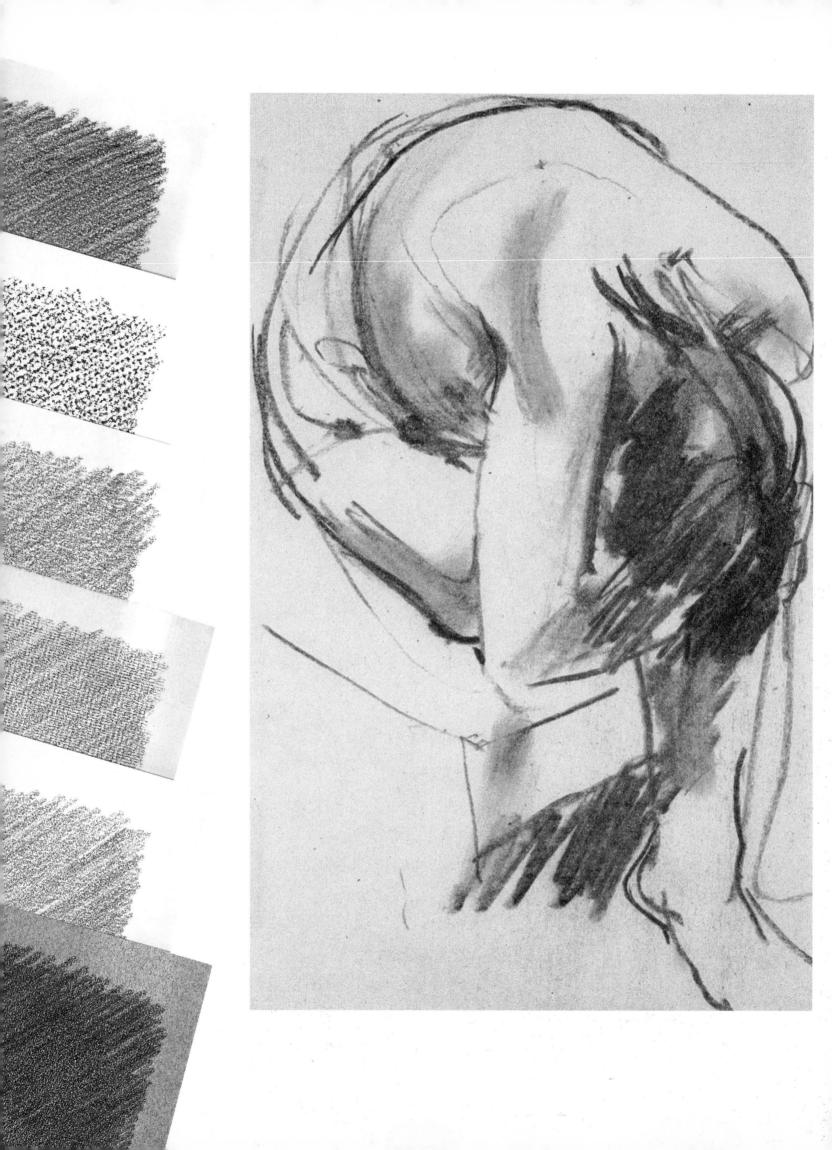

pensive. Tinted papers, such as Ingres pastel paper, take pencil, pen and ink well, but almost anything can be used, though much depends on whether you are playing about with ideas, doing preliminary drawings, or intend to spend time on a finished pencil drawing good enough to frame. Sketchbooks are very handy, especially for on-the-spot work outdoors, as they usually have a thick cardboard back.

When sketching outdoors there is much to be said for having with you a variety of different papers, of various colours and thicknesses, some with texture, some smooth – some very smooth such as 'art' paper, glazed with china clay. A hard pencil such as 4H produces a crisp clear line on such paper. There are various smooth papers having trade names and sold in pads of different sizes, with perhaps the very best surfaces for pen-and-ink work.

For those who prefer pen-and-ink to pencil, who like the bite of a nib on paper, there is a stimulating and rewarding alternative – scraperboard. This is a prepared black board and when you draw on it with the point of a scalpel or craft-knife, or a rigid nib such as a 'J' nib, or the special instrument sold for the purpose, the lines are left in white, like a photographic negative. The final effect is stark and crisp, and it is a method which can give you a beautifully sharp and stylish result. Scraperboard is also made in white, so that an incised line shows up black (just like pen-and-ink). Of course, on scraperboard you have to get your light and shade by texture, by hatching, by stippling with Far left: A selection of papers used for drawing, showing how the different finishes and textures affect the character of the drawing.

Left: Study of a nude girl, carried out freely and spontaneously.

Below: The various degrees of blackness achieved by pencils, ranging from 4H to 8B, charcoal and Chinagraph pencils.

4B

Charcoal pencil

Chinagraph pencil

Four different types of easel. The one on the extreme right is easily portable and ideal for outdoor work. The others are mainly used indoors.

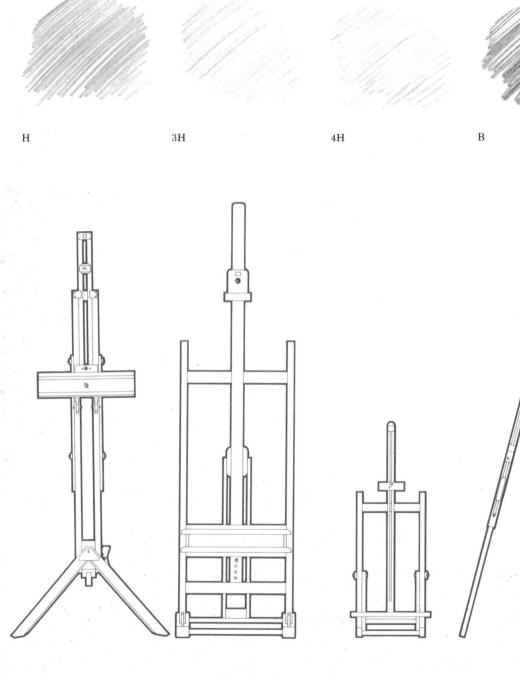

15

dots, but it is worth while taking the time to get to know it as the final results can be dramatic. Scraperboard and the nib-like tool are very reasonably priced. No doubt those experienced in this kind of work can begin using the tool right away, but otherwise it is best to work out your subject on the surface in pencil or Indian ink. A marvellous effect can be produced by using watercolour on top of the finished scraperboard drawing.

Drawing Board The best drawing-boards are keyed, battened and proofed against warping and shrinking and all the other ailments wood is prone to. The most useful attribute of the drawing-board is that it takes drawing-pins, which alternatives such as a piece of hardboard will not. A drawing board of the traditional kind can be very useful in a life class where the drawing is on a vertical easel. A proper drawing board has just the right amount of give to a pencil point; a substitute may be too hard and shiny. Some people prefer to tape their drawings to a board with adhesive or masking tape (preferable, as it is easier to remove from the paper edge).

Easel Often looked on as an optional extra, an easel, especially a small portable one, can come in very handy, even for drawing. In out-of-doors situations it is often a good thing to stand back from the picture to see how it is going. Some artists never use an easel at all, even for doing oils, so it is very much a personal choice. Drawing at a vertical angle is altogether different from drawing on the flat or on a slope.

A very useful easel is the table-top type which works on the ratchet principle, so that the angle of the drawing-board can be altered to suit the artist. Some portable easels incorporate a fold-up stool. A fold-up canvas stool is better than a fold-up chair as, if the latter has arms, they tend to get in the way. An easel can always be improvised by using the back of a chair.

Erasers There are three kinds of pencil erasers on the market: the putty type, which can be very tiresome and crumble up into black pellets but which are ultra-soft and good for toning down blacks; the traditional office-type eraser; and the plastic type which has largely taken over from the second group as it is 'clean' and very versatile.

Charcoal At one time every art student wielded a stick of charcoal in the life class, and it has much to commend its use. It produces a soft black, which is easy to rub out even with a fingertip. However, it is not very suitable for

fine detail and students are inclined to work on a larger scale than they would do with a pencil. This was considered a good thing by art masters, who had a paranoiac fear of niggardly work. Used on its side, it is very good for blocking in shadows, rather than hatching them in with a pencil.

Charcoal can be sharpened to make a point; small blocks of very fine-grained glass-paper are manufactured for putting points on charcoal and pencils. Soft bread kneaded between the fingers makes a good eraser. Try not to buy charcoal with a hard core, though this may be difficult as charcoal is normally sold in packets on a take-it-or-leave-it basis. The best way to hold charcoal is between the thumb and the first two fingers, with the thumb uppermost. Try to keep the hand off the paper and draw from the elbow. If you are using charcoal always keep a fixative at hand; an aerosol is the most convenient, but a fixative can also be spraved on with a diffuser, which consists of two metal tubes hinged to make a right-angle. One tube is longer than the other; you dip this in the fixative, and blow through the shorter tube. A vacuum is created above the opening of the partly immersed tube, the liquid is drawn up and forms into a fine spray. Diffusers are cheap and efficient.

Conté Crayon This is not a school crayon, but a traditional artist's material made in France and used by the great French artists of the nineteenth century. It is sold in pencil form or in rectangular blocks and is used as it comes, not sharpened to a point. It gives a lustrous deep black, and has amazing covering capacity. Used with textured paper it gives a mottled appearance. It is very good with watercolour, but if used with what might appear to be its natural associate, pastel, it is inclined to slide as it is slightly greasy. It comes in a variety of colours, though black is by far the most useful. Many of the French artists used a colour called sanguine, a browny-red.

Torchon or Stump These are pencil-shaped articles of compressed blotting-paper or similar material, used for spreading charcoal, or cleaning up edges, and also useful in pen-and-ink work where they can tone down colours or blot out mistakes. Cotton-wool buds as sold in chemists can also be used, particularly for detailed work.

Of course other accessories can be added to the basic materials when needed. A toothbrush can be used in pen-and-ink work to 'spatter' ink on to a surface, and sometimes drawings develop into watercolours or pastels, so always have the necessary equipment nearby.

IS DRAWING DIFFICULT?

Learning to draw is like learning to play the piano, only easier. The classic form of drawing is reproducing something in front of you, whether it be a bunch of grapes, a nude or a landscape. In the art schools of yesteryear there was no chance of you touching a paintbrush until you could do this. This is why the artists of the past were very accomplished; whether they were imaginative or at all interesting is another matter. The first thing to do if you are drawing from life is to forget what you know; you are drawing what an object looks like, not what it is – unless, of course, you do not want to be representational, in which case you can draw what you like.

It is interesting to speculate on why prehistoric man made his cave drawings of animals. The most commonly accepted theory is that drawings were a form of magic, and that by depicting animals with spears in them he would be rewarded with success in the hunt. To the professional artists of the Middle Ages and after art was for the glory of God. When they painted Jesus and the Madonna they were not concerned with where the shadows went. Putting in a halo of gold leaf was more important than verisimilitude. When considering the present day, and ignoring for the moment that the Romans and the Egyptians could depict *exactly* on panels and walls what they saw, we

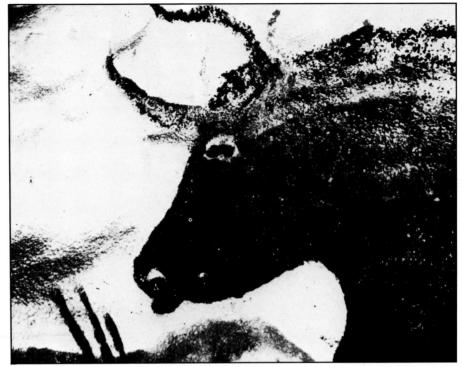

can see in children's art the wish to put down on paper what they know rather than what they see. A circle with two blobs, a vertical stroke, and a crescent shape at the bottom is a face, a rectangle with four squares, an oblong, and another oblong at the top exuding smoke, represent a house (even for those in tower blocks who only see a house once in a blue moon).

Some people, including artists, never lose this way of looking at objects, or, rather, pretend not to have lost it. The childish vision allied with a solid technique can often be a money-spinner. Art teachers are usually the first to try to eradicate the child's way of depicting external objects, and place before the class cubes and spheres and other dreary objects. No wonder that many children do not find much fun in drawing.

Some people, adults as well as children, may, when drawing a picture, put down an outline and then colour in the enclosed areas. This may be instinctive to them, though if you reflect a little you will realize that an outline does not exist 'out there'. An outline is only a dividing line between an area of light and an area somewhat darker. In other words, an outline is a convention. It is a convention that in drawing all artists will continue to respect –though not in painting, where changes in *tone* (not colour) are all important.

In drawing, except when using coloured pencils or coloured inks, all we have is outline and tone. Our aim is to depict with reasonable accuracy what we see. Success does not depend on manual dexterity but on looking and Prehistoric wall paintings, which can be interpreted in many ways, as magic symbols or even as reminders of successful hunting missions. There is no mistaking their immediacy and verve. These early artists were not bogged down by methods and techniques but drew directly on the walls, using charcoal, earth or any material to hand. Here is an excellent example of freedom of style unfettered by too much discipline.

Left: This child's painting is totally uninhibited in its freshness, a quality which becomes more and more elusive with age.

In the above pencil drawing, the artist obviously wished to chisel out every small detail, starting with a hard pencil and finishing with a soft one to render tones.

Details.

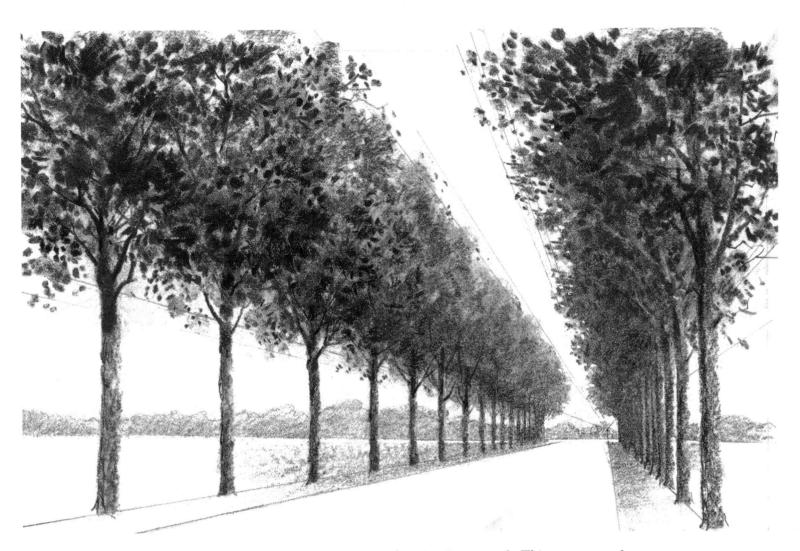

assessing. By assessing we mean simply seeing how certain shapes relate to other shapes and how light or dark they are in respect of each other. Sometimes the shapes are simple, and can be looked at once and set down with something like accuracy. In landscape it can be a farmhouse set against a field. Sometimes the shapes are complex, such as the angle of a wrist in a life drawing. No shape is too difficult to put down. We do not have to know how the farm was built and its methods of interior construction. Nor do we have to be anatomists to find out why the wrist turns in one way and no other, though it is only fair to mention that artists of the old school needed to be well versed in anatomy (and sometimes robbed graveyards for specimens to dissect). These are the principles behind drawing, and after a time it becomes second nature to recreate on paper the external appearance of something. The next stage is using the drawing, either as a basis for something else or as a spur to further composition.

Once we realize that the outline is only a means to an end and that the effect of *solidity* is far more important than a pencil line surrounding a white silhouette, then the main barrier to accurate drawing is crossed. This may sound daunting for some, who believe that they will never be any good at drawing. Useful as the skill is, drawing is not the be-all and end-all. It is quite possible to be a bad draughtsman yet a good painter. There are a large number of short cuts that can be taken, and there is no need for anyone ever to bother drawing something from life if he or she does not feel confident about it, though it must be said that although it is a kind of discipline it is great fun, and it is fascinating to see a drawing gradually emerge from the first marks made on the paper, whether it is a bit of shading, a few squiggles to mark where the shapes come, or a fragment of line.

Before we pursue the practical side of drawing, a few words on the subject of perspective.

Perspective

Perspective is a simple matter. If you look at a straight road going towards the horizon it appears to narrow; a person walking along this road appears to get smaller as the distance increases between you and that person, losing height at the same rate as the road narrows. Telegraph poles will appear to shrink. If the road extends as far as the eye can see, the sides The amateur artist needs to be aware of perspective. In this pencil drawing the avenue of trees recedes into the background, converging to a point where it disappears.

These diagrams show one of the basic rules of perspective. In a manner similar to that shown in the previous drawing, if one were to continue the lines of the house roof they would recede to a point in the distance, i.e. the vanishing point. Diagram 1. Perspective as seen when the level of the eye is in line with the base of the house. Diagram 2. As seen from above the house. Diagram 3. Looking at the house on the normal level. Diagram 4. When one looks at an object from a distance, the vanishing points are less acute.

Right. Before starting a drawing, decide where your vanishing point will be. Diagram 1. Choose your vanishing point and draw in the basic lines of convergence.

Diagram 2. Start to sketch in the details. Guidelines can be erased at this stage.

Diagram 3. Finished sketch.

will appear to meet at what is known as the vanishing point on the horizon. The horizon is *always* at eye-level, and to prove it, sit or lie on the ground and watch how the horizon goes down with you. The horizon has *nothing* to do with the sky-line, and the only time to observe a true horizon is at sea where the sky meets the water.

Objects above or partly above the eye-level appear to go down towards the horizon and those below appear to go up. If you look at the roof of a house from any angle except directly in front, you will see it obeying the laws of perspective. If you extend the roof with an imaginary line it will lead to the horizon at its own particular vanishing point. There is only one horizon line, but there can be any number of vanishing points in any one scene. Without using perspective, a drawing or a painting will be flat, a mere pattern. Using perspective you get solidity and recession; you can place things in space with absolute certainty that you are getting the relative sizes right, because everything fits into the pattern.

In working from the imagination, the horizon can be as high or low as you wish. If you are doing aerial views it can even be off the top of the paper. But objects still recede towards it according to the rules. The laws of perspective must be used. Use perspective to help establish objects in space, and twist it if you need to get a better effect. The experts in perspective drawing are not usually artists, but architects. Their perspective has to be absolutely right, but if an artist's perspective looks right that is what matters. It is easy to imagine roads, roofs, and telegraph poles going conveniently towards vanishing points. Asymmetrical objects such as oval-shaped ponds also obey the laws of perspective, and nobody in their right mind wants to work out *exactly* how perspective works on them. If you are drawing from life, you can see; if you are not, but would like to put in an oval pond somewhere, you put one in and see if it looks right.

A brief mention should be made of accidental vanishing points. Surfaces which are tilted (academically described as 'surfaces which are inclined to the horizontal') *sometimes* converge on accidental vanishing points which lie above or below the horizon – and not on it. A good example of this is a road going uphill, where the sides will appear to converge at a point *above* the horizon, vice versa in the case of a road going downhill. This fact is another reason for not being too much in awe of so-called laws.

There is a useful tip: an object twice as far away from the viewer as another identical object appears to be half as tall; if it is three times as far away it seems one-third as tall; four

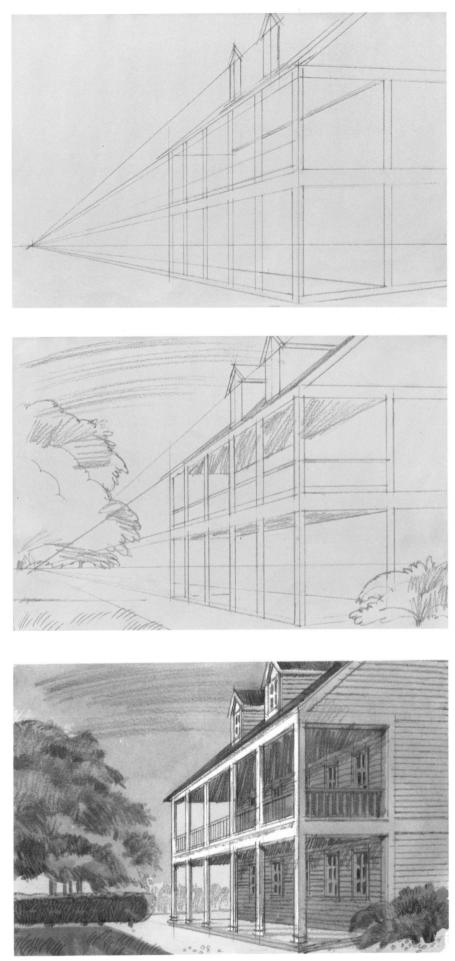

The New York skyline is a classic example of aerial perspective. Buildings in the front of the picture can be seen in detail, but the misty, blue quality of the background suggests distance. times as far away, a quarter as tall, and so on. Another useful tip is: even in good drawings and paintings the clouds sometimes seem flat and uninteresting. This is because clouds are also subject to the laws of perspective.

Aerial perspective, oddly enough, does not have anything to do with ordinary perspective. You might think it means aerial views, and how objects on the ground have vanishing points outside the picture surface (or, if seen from directly above, have no vanishing point at all!) This is not the case. Aerial perspective is the effect of atmosphere. Atmosphere is full of moisture, dust, not to mention noxious fumes, which tend to obscure the most distant objects. The more distant objects are, the more they are obscured, and the lighter or higher in tone they will appear to be. Distant features often take on a bluish tone, and 18th-century artists had a formula that was worked to death – dark brown for the foreground, green for the middle distance and blue for the far distance. This became a device for achieving a good effect without much soul-searching. In the early morning, distant objects can be as crisp and un-blue as you care to imagine. So aerial perspective is something we can take or leave, depending on the effect we want.

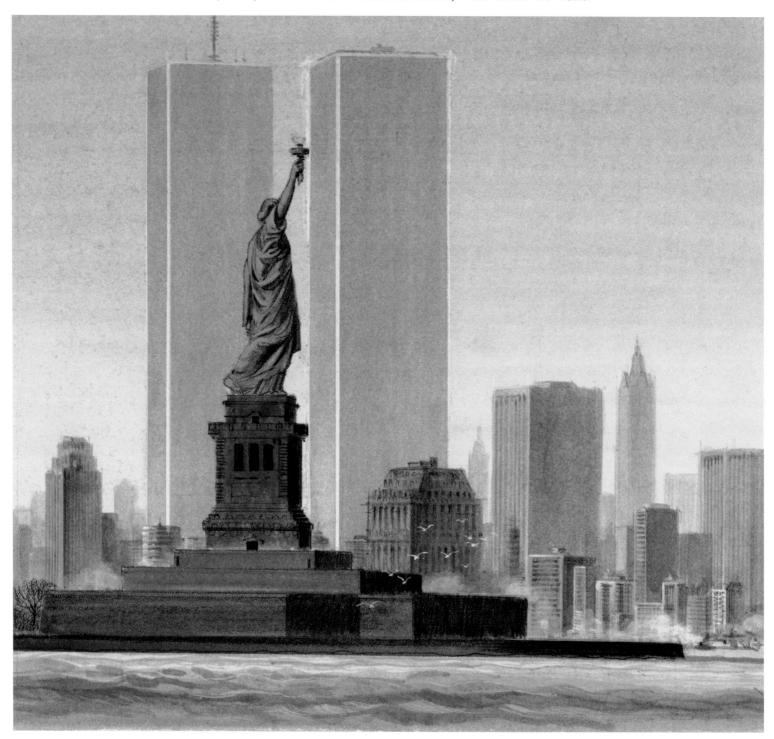

HOW DO I START?

In most cases, it is not a question of starting but of continuing. Most people have drawn at some time in their life, even if it is only a doodle on a telephone pad. The main question is: do I want a challenge or do I want to take the easy way? The challenge is to do *something* from real life and get professional or amateur opinion on your drawing as the work progresses – in other words, join an art class or a sketching club.

Lessons at art classes are cheap, especially if organized by the local community. The ultimate challenge for beginners is to join a life class, and paint the nude figure. The models in life classes have to stand still and be drawn or painted, which is actually very hard work. If you are worried about not being good enough for the class, do not be. Most adults who go to life classes are *not* very good at drawing, and some of them never will be because they go simply for an enjoyable night out and because of the people they meet there. Many of them do not particularly want to improve, and others do not take kindly to any form of instruction from the teachers, who consequently have to be masters of tact and diplomacy (and usually are – the traditional stuffy ones are a dying breed).

Sketching clubs are usually concerned with landscape, which is easier than life drawing (in this context life is drawing from the nude). Experienced artists often go with sketching clubs, for the sake of companionship and comfort. For those sociably inclined, there is a lot to be said for sketching clubs, which usually include experienced artists as well as learners. There is no easier way to pick up techniques and tips almost by accident. Overlooking a good artist at work can be very rewarding, and it is amazing, by simply looking around, how many styles and methods of drawing and painting you find there are. You should keep a sketchbook with you at all times as you never know when an opportunity will arise to sketch a friend or an interesting object.

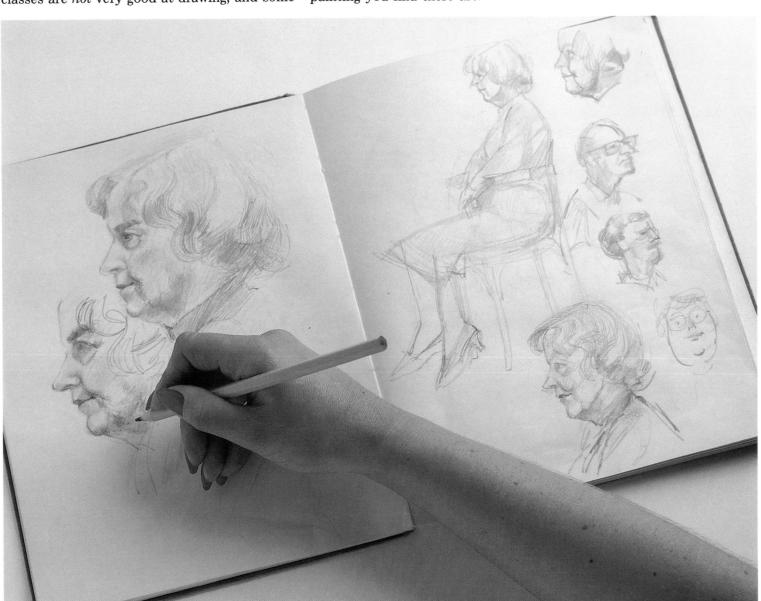

When out with a group – sketching landscapes, for example – it is a good idea to sketch some of your colleagues as they will invariably be standing still, deep in concentration on their own work.

Drawing at home, watched occasionally by a husband or wife, father or mother, or, more unnerving, children, may or may not be more acceptable, but it is important to give yourself something of a challenge. Do not spend too much time drawing something which bores you to distraction; if you feel that you ought to try a still life, set up an interesting group, and if the drawing is going badly finish it quickly and turn to something else which is more stimulating, whether it be the dog curled up on a carpet, a self-portrait, or a view from a window. There is no obligation to do pretty or picturesque subjects, nor any of those tiresome exercises middle-aged men and women remember from their school-days. If it is not enjoyable it is not worth doing; nobody is paying you, and if it becomes a chore you might as well settle down in front of the television screen.

The whole emphasis of this book is on pleasure. If you would like to go out with a sketchbook but feel that you will look foolish, go in the car and stay in the car while you

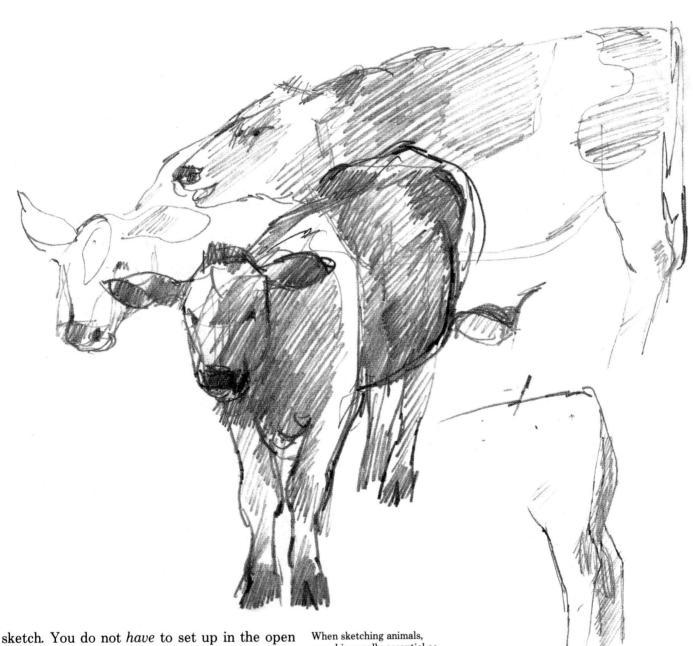

sketch. You do not *have* to set up in the open air with all the paraphernalia associated with a 'real artist'.

But there is a lot to be said for outdoor sketching. It can be a means of gathering material for future work. Suppose you have decided to draw a quaint group of riverside cottages, not because of any deep interest in cottages but because it is a traditionally picturesque subject. Maybe there are boats on the river, and you decide to turn your attention to them as the cottages are beginning to seem rather dull. Suddenly you hear a clock strike in the distance and you realize that you have been busy sketching the boats for an hour, and in doing so you have found a subject you are really fascinated with.

Even if you go to the same place time and time again you will always find something different, for weather conditions are never exactly the same, and there will be details which you will see for the first time. Certainly at some time you will find a subject you will not When sketching animals, speed is usually essential as they are constantly on the move, in contrast to the seated figure, lower right.

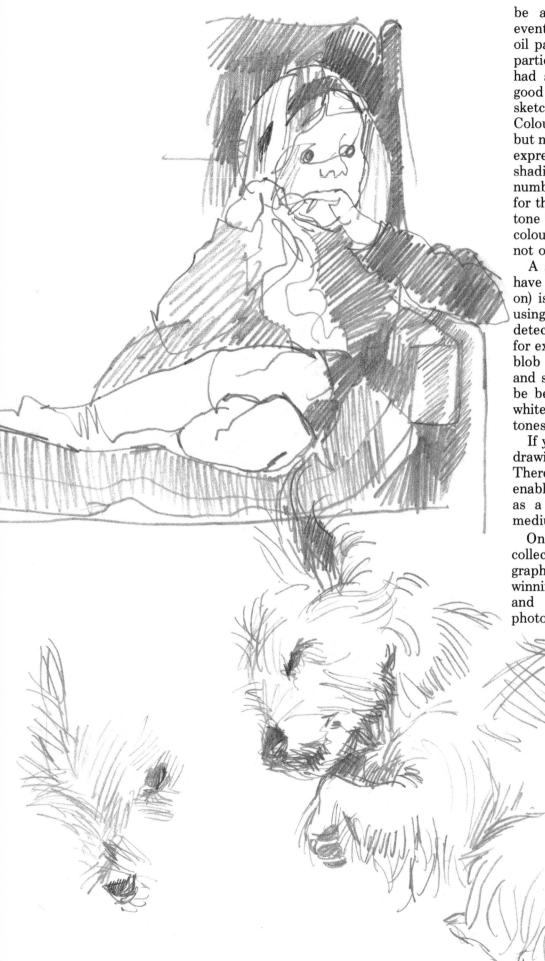

be able to let alone, and the sketch will eventually form the basis of a watercolour or an oil painting. If you had not been there at that particular time you would have missed it. If you had seen the view, thought it would make a good subject for a painting, but had not made a sketch, how much would you have remembered? Colour is fairly easy to retain in the memory, but not tones. Of course in drawing you have to express the tones with degrees or kinds of shading, but if they can be graded you can number them, from one to six for example, one for the lightest, one for the darkest tones. And tone is always far more important than colour; colour is to be used to make an effect. It does not or should not use you!

A substitute for sketching (if the idea is to have something to base an oil or watercolour on) is the use of a camera but, unless you are using filters, distinct tones which you can detect with the eye may be merged into one, as for example in a cloud, which is not a flat white blob but a subject having its own roundness and space. If you are taking a camera it might be better instead of colour, to use black-andwhite film which will give insight into the tones.

If you feel that you will never be any good at drawing but want to paint, do not despair. There are any number of short cuts which will enable you to set down some kind of 'drawing' as a basis for painting, whatever the paint medium.

One of the greatest aids to artists is a collection of illustrations, photographs, photographs of people, landscapes, seascapes, prizewinning photographs, photographs in books and catalogues, snapshots, Polaroids and photographs of pictures, to mention only a few

> The home is an ideal place to sketch children and pets. Children sometimes remain conveniently still while watching TV. The delightful West Highland terrier was captured on paper while fast asleep.

When the family have become accustomed to your sketchbook they will be only too pleased to pose for you.

examples. Most artists of the past accumulated illustrations; before the 1840s they were prints and paintings; between 1840 and about 1880 photographs were added to the collection, but these photographs were 'one-offs' as no way had been found to reproduce photographs in books except by sticking them in with gum. These photographs were all monochrome; colour photographs were not developed for a long time. Today colour photographs are available, and have been for over half a century. They form a valuable source of information, though black-and-white photographs can be even more useful as an aid because they deal with tone, which to an artist is more informative than colour.

Commercial artists rely very much on their photographic collection and are not shy to admit it. A number of the very best commercial artists keep photographs cut from newspapers, periodicals and magazines in folders, each labelled with its contents – men and women walking, action, games, children, uniforms, back views of people, restaurants, shops, cars, trains, and so on.

Photographs can be consulted, and for those for whom drawing is their weak point, they can be copied - or even traced. If all you want is a basis for a picture, not a drawing to be proud of, there is much to be said for tracing. There is no need to trace an entire photograph – just the elements you want. Photographs can always be copied, and an advantage of copying is that the replica can be executed on a larger scale than the original by 'squaring-up'. Squaring-up is a traditional way of transferring a preliminary drawing on to a canvas, and all it means is that the drawing and the canvas are divided into squares. The numbers of squares on the drawing and the canvas are the same, but as the drawing is usually smaller the squares on the canvas need to be larger. The same can be done with a photograph.

A splendid short cut to squaring up is to make a grid. Take a small pane of clear glass

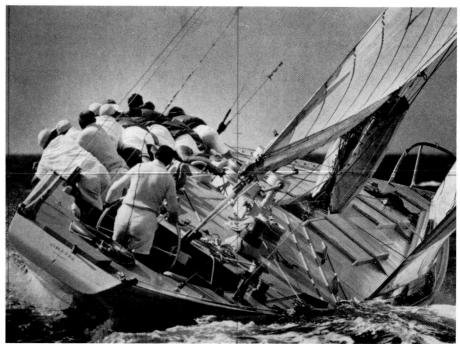

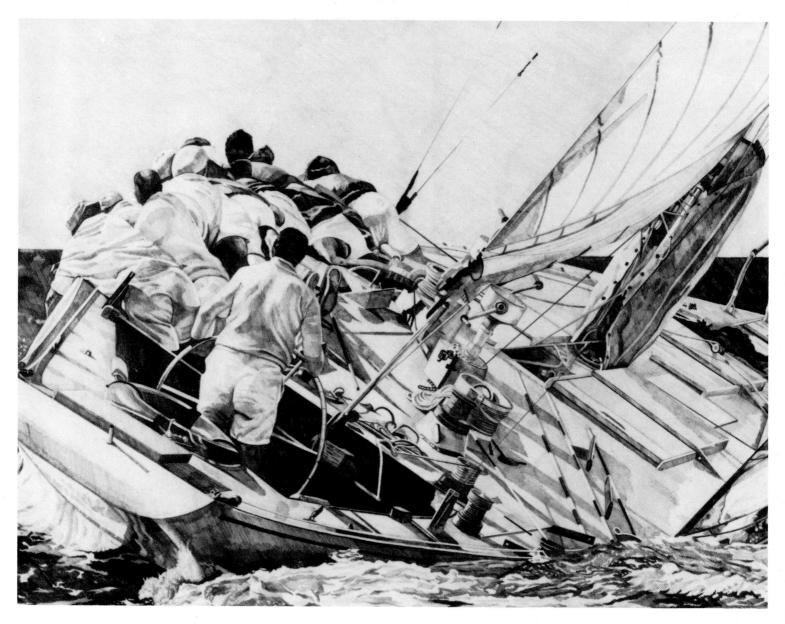

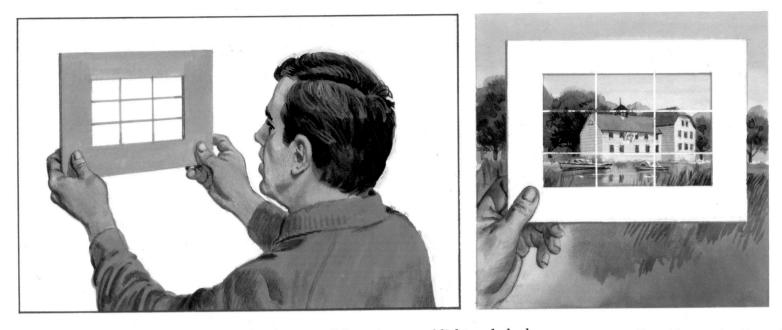

and divide it into squares - half-inch or oneinch as you prefer – by stretching thin strips of self-adhesive tape at appropriate intervals to divide the glass. Or you can paint the lines in by using a small pointed brush and acrylic paint. It is also a good idea to make a grid when you are using a home-made viewfinder (a piece of card with a rectangle cut in the middle). Stretch white nylon or cotton at the appropriate intervals across the aperture, so that when you look at your view it is conveniently divided into squares. Do not use the thinnest gauge cotton or nylon for if your eyes are focused on a distant scene you will not be able to see the grid properly.

Originals can also be copied, larger or smaller, by using a device called a pantograph, which is something like a flat wine-rack with interchangeable struts, a pointer to follow the lines of the original, and a pencil at the opposite end of the device for reproducing the picture. If you do buy a pantograph get a good one, and not a cheap plastic type which is no better than an irritating toy.

When using the squaring-up method it is simple to copy the material seen in each square, ensuring that the proportions are correct, which is vitally important in figure and portrait work. Many of the great painters of the past have used this method, and it is wholly acceptable. More artists than you might imagine have used tracing as a basis for transferring designs onto paper or canvas. The only problem with tracing is that unless one has a darkroom and photographic ability (or a good deal of money) photographic prints are relatively small, except in 'coffee-table' books, a source of illustration not to be overlooked. It is amazing how you can build up a picture using various photographs, even though it means altering the different areas of light and shade.

Among the most useful photographs are those you have taken yourself. A photograph not only jogs the memory, but is also valuable as a record; it can replace a sketch done on the spot for working-up later into a picture, or it can supplement a sketch. Using a Polaroid camera during sketching can be very rewarding, for bringing out features in landscape which you have overlooked, and establishing the exact look of a place, as well as the general colour and tone. Few professional portrait artists work without recourse to a number of photographs of their sitters. So it is not unreasonable to use a camera.

So far we have been dealing with photo-

Above: A home-made grid or viewfinder makes a good device for transferring a smaller image on to a large paper or canvas.

Far left: Squaring up a photograph or a magazine cutting is an excellent way to enlarge a drawing.

Below: A pantograph can also be used to reduce or enlarge an illustration.

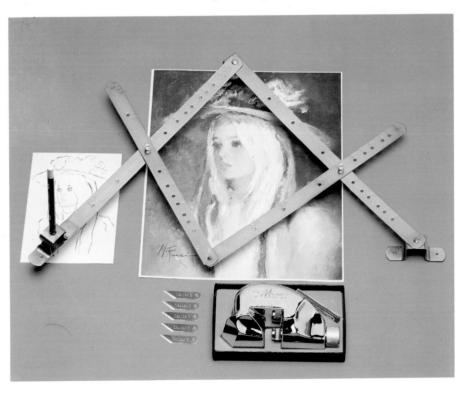

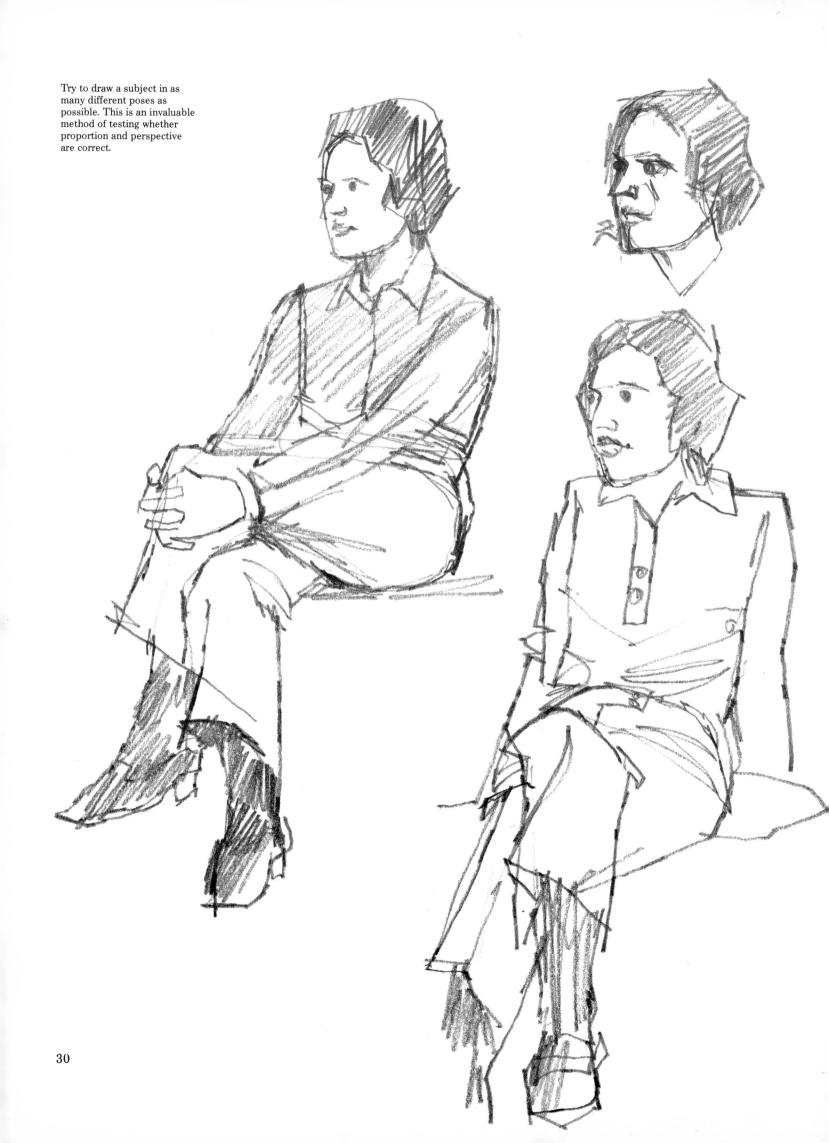

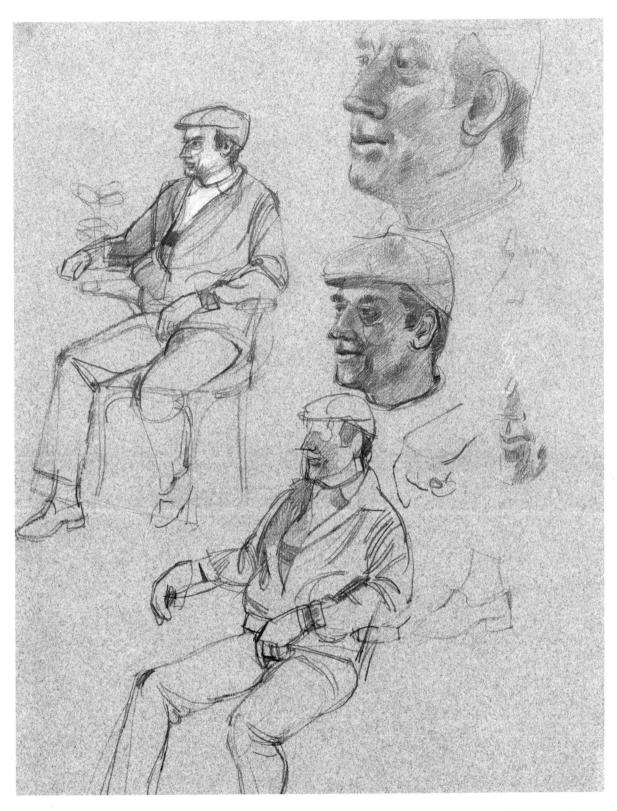

Having quickly set down the basic shapes and forms, the artist has decided to make a further sketch of the head in some detail. This is a good idea in case you decide to do a full portrait at a later stage.

graphic *prints* as an aid to or a substitute for drawing, but colour transparencies can also serve a purpose. They are not so easy to flip through in search of subjects or information, but unquestionably they have their place. The image on a transparency is, of course, thrown onto a screen. Provided that you keep out of the way of the light source and substitute paper or canvas for the screen there is no problem in painting the picture as it is being projected – painting-by-numbers with a difference. It is the procedure of highly regarded artists of the neorealist school in the USA, and is no more reprehensible than collage, the use of silkscreen printing, and other dodges of contemporary art. If it suits you, and you like doing it, do it. You may think of other useful techniques.

Squaring-up is one of the traditional methods, and it takes time. There is also bound to be some deviation from the original. The slide projector is limited because it naturally only uses slides, and invariably most of the slides are home-made.

The episcope is well worth considering. This is a device in which an illustration of any kind – black-and-white or colour - is placed face down on a window and projected onto a screen or other suitable surface by means of mirrors, a lens, and a strong internal light. The size of the image can be altered by adjustment of the lens, and the quality is as good as that provided by a slide projector. As with a slide projector, the picture projected can be drawn or painted on directly in almost any medium, though as the screen/paper/canvas is vertical any watercolour needs to be applied with discretion for otherwise it will run. Because the image stays perfectly still for hours on end you can spend as much time as you like drawing in or painting in, using small dots if you wish, every so often putting your hand in front of the lens to black out the light to see how the work is going. This avoids switching the machine on and off, which reduces the life span of the specialist bulbs. When setting up the episcope, place it so that you are not working in your own shadow - if you are right-handed have the episcope positioned on your left. For those who intend to do a lot of work with the episcope it is worth while considering fixing up a stand, so that the machine can be placed above the working surface with the lens pointing downwards.

Another method of drawing is by using computer graphics. Many home computers and word processors have 'add on' extras which make it possible to use a VDU (visual display unit – the television monitor) as a drawing surface. These computer-originated drawings can be printed out, and with the aid of simple inexpensive devices can be altered in all manner of ways – squeezed, enlarged, chopped about – and by using different coloured ribbons in the printer they can be coloured.

A casual mention must be made of video as an aid to artists. It cannot be used directly, but it can be a valuable source of information on every subject. In the old days an artist who wanted to study the sea and analyse the structure and pattern of waves had to go to the sea to look at it. If you are keen on doing maritime pictures, you can always find a television scene involving the sea, even if it is in the middle of a feature film. Such a section can be played over and over again, with certain episodes frozen to see exactly what waves look like. In today's world we can find out about almost everything without needing to go out-ofdoors. How documentary-type artists of the past would have envied us!

Copying, tracing and reproducing are all

When making a tracing it is important to put in not only the outline but the shading as well.

Tracing the image.

Following the lines on the reverse side.

Retracing the lines.

shortcuts to painting, bypassing the process of drawing and the co-ordination of hand and eve. No one is going to award you a prize for diligently slogging away at a drawing when you are not really enjoying it, and if you happen to turn out a good painting very few are likely to enquire about the initial techniques you used. Copying, using the squaring-up method or freehand, needs little said about it; for tracing one needs a pad of proper tracing-paper as sold by art shops, not too thick and not too flimsy. When tracing, put in the tones as well as the outlines. There are two main methods of transferring the tracing onto paper or canvas, first, by using carbon paper. This is all right when using opaque watercolour or oils, but in watercolour proper the carbon lines are too dark and do not rub out easily. The second is to do the tracing, turn it over and rub the reverse of the outline with charcoal or soft pencil. Then apply the tracing paper right way up and go over the detail with a hard pencil (HB or H) or a ball-point pen. Charcoal has the slight edge on pencil as it is easily removed or obliterated by almost any medium from the lightest watercolour upwards. If there is a slight disadvantage with charcoal it is that the image can be a little 'fluffv'.

Let us suppose that you have not taken the easy option and are willing to draw something in front of you. Whatever you are drawing, you must decide whether to stand at an easel or sit down. If you are sitting down, you can have your drawing board or sketchpad on your knees, or on a table. If you are sitting down and want to work on a vertical surface but have not got an easel, two dining-chairs tied together by the front legs make an excellent substitute, if you sit on one and rest the drawing board on the back of the other. Large-scale work is better done standing up, as the action comes from the shoulder rather than the wrist so there is greater freedom.

The way you hold the pencil is a question of taste; in writing it is held between the thumb and the first or second finger. In drawing, try holding the pencil with all four fingers beneath it, thumb on top, and knuckles against the paper. This is for standing up. For sitting down, reverse the procedure, and in both cases it will give you flexibility if you hold the pencil loosely and not too near the point. For pen-and-ink work it is also worthwhile trying new ways of holding the pen.

In drawing any object, establish roughly what you intend to put in. In a still life, it is quite simple; you make the arrangement, so you put it all in. In a nude you will *try* to include everything, but sometimes the odd ankle just does not fit into the picture. Landscape has to

There are many ways of holding the pencil or other drawing instrument, and you will find the method which suits you best.

General sketching work.

Shading large areas.

Detail work.

Using the pencil as a measuring device to get proportions correct.

be cut off somewhere, and you may decide to put the most interesting features in the middle and let the rest take care of itself. Alternatively, you can make use of a viewfinder, which you can easily make yourself out of a piece of card, and it is nothing more or less than a small picture mount with a convenient-size rectangle cut out of the piece of card. A camera view-finder can be useful. In portrait drawing obviously the whole of the face must go in, and the rest you can leave rough or finished as you wish.

The very first step is to get something down on the virgin paper. There is nothing more demanding than an empty piece of paper. You may like to put in a few light touches indicating the size and position of the subject, or you may care to start by indicating the areas of shadow with the flat of the charcoal or by hatching with a series of parallel lines. If they are wrong, it does not matter; do not rub them out. As you become more certain that you are on the right track, lines and shadows can get firmer and more authoritative. Fashion designers usually put in the entire outlines, and then fill them in. If you have a good eye, you can do this but it is normally only possible with practice. It is usually easier to move from point to point, from drawing fragments you are reasonably satisfied with, whether they are bits of outline or areas of shade, to new sections.

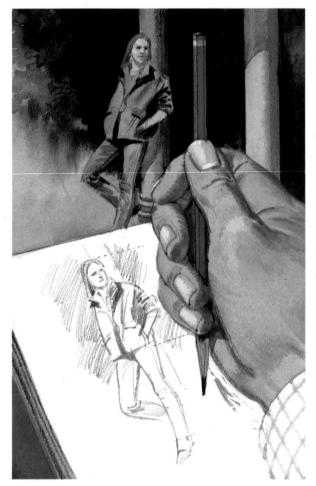

Seat yourself at a distance from the model to enable you to draw your picture to the exact size of your visual image.

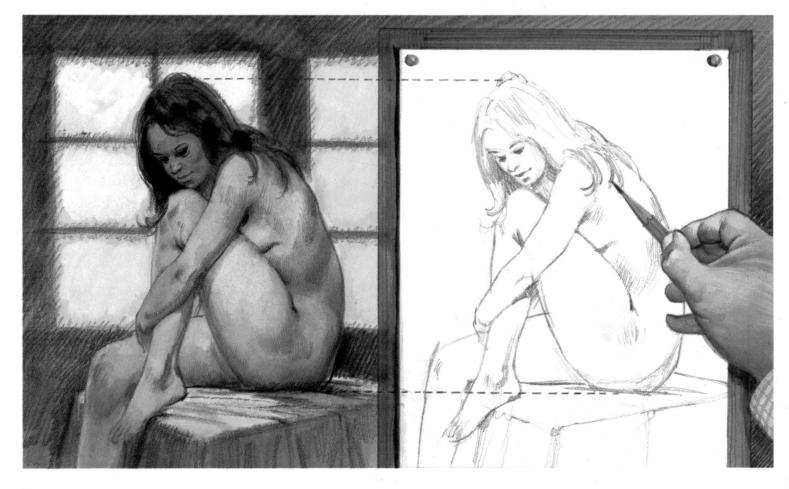

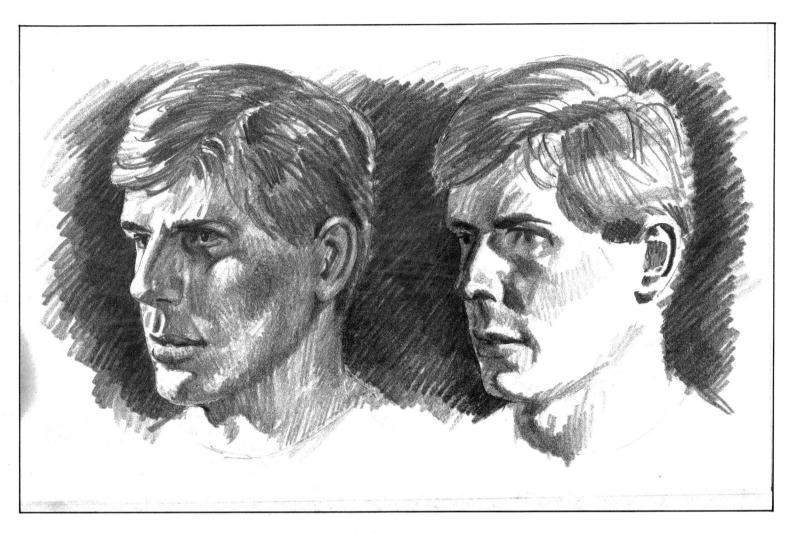

In the early stages it is very easy to come adrift on questions of proportion. A pencil held at arm's length is very helpful; the distance between point A and point B can be equated between the tip of the pencil and the top of the thumb nail. There is nothing to stop you using a 12 in wooden ruler for this task. Divergences from the vertical and the horizontal can also be figured out with the help of a pencil held at arm's length. It is easier to under-estimate an angle than over-estimate it.

Shadows come in all shapes and sizes, and because we are not really used to examining shadows, there are more varieties than we might imagine. There are shadows arising from the object part being away from the light source, there are background shadows, and there are cast shadows, in which one object is shielding another object or part object from the light. Cast shadows are darker than other shadows. If there is more than one light source, the shadows can be very interesting, and you may decide which ones you want and which you do not. The usual way to draw a shadow is to hatch it, but you can also use dots or scribbles; for strong shadow you can use cross-hatch, in which parallel strokes from right diagonally down to the left (or vice versa if you are lefthanded) are overlaid by parallel strokes top left to down right. Or if you are using a soft pencil with a chisel point you can put the shadow in solid black. Try to build up the drawing with a combination of outline and shading; they complement each other. This applies to all types of drawing.

If you are setting up a still life at home or are drawing a husband or wife you can decide for yourself what source of light you want. The only advice is not to have the light source immediately behind the subject. A room with windows on one side only provides more comprehensible shadows than a room with several light sources; for really direct shadows, nothing is better than electric light with an unshielded standard lamp or adjustable lamp better than an overhead bulb or fluorescent tube.

In landscapes we have to depend on the sun, and if we are interested in drawing for drawing's sake it is better to go out when the light is good, as well as in the early morning or late afternoon when the shadows are at their most interesting. Needless to say, there are no hard or fast rules about this; atmospheric drawings can be made on occasions when a photographer would hardly get a reading on his light meter. Place your model near to a window or other good light source if you are looking for a dramatic effect with light coming from a specific direction. HAVING STARTED THE DRAWING, HOW DO I CARRY ON?

Your drawing may at this stage look like tea leaves in the bottom of a tea cup or automatic writing at a spiritualist seance. It does not matter if you have bits of outlines and areas of shading as long as you have an idea, however vague, what is going on and are not merely putting in strokes and blobs at random. It is more important that you can see a way to get to grips with the subject, and can assess it as a whole, knowing from which direction the light is coming and what will be the stumbling blocks needing extra effort. If you find it difficult to work out the tones, and cannot decide which areas should be darker, half-close your eyes and look at the subject again.

Every drawing exercise has its difficult aspects, and sometimes it is a good idea to tackle these separately, on a separate sheet of paper or on the corner. In still life, it may be the curvature on jugs or bowls and how to put in the graded shading as the curve moves into the dark, or it may be that you are tackling a vase of flowers and wondering how to manage those flowers partly in the shadow of blooms above them. In landscape, it may be the problem of depicting trees so that they do not look like overgrown cabbages. In life drawing, a common disaster area is the hand and wrist, and even great artists can come unstuck. In portraits, you may have a problem in preventing the subject looking cross-eyed. Each of us has a particular area which we find fraught with difficulty, even if there is no sensible reason why this should be so. However, you must persevere and try to crack it. If a hand looks like a melon, rub it out and start again, though it may be that you have already gone over it a dozen times and the lines and indentations are beyond redemption. If the rest of the drawing is going well, it is much more convenient to paste a piece of paper over the offending part and carry on over that (adhesive envelope labels are ideal for this purpose).

There is no substitute for looking *hard* at something which is proving intractable, and this is where a photographic collection can be invaluable. Examine what the difficult object *really* looks like and how painters and draughtsmen of the past have managed to make their efforts believable. It is sometimes a good idea, even if you are a dedicated non-copier, to copy a detail from another picture and in so doing realize where you went wrong. Many of the problems of drawing derive from the fact that

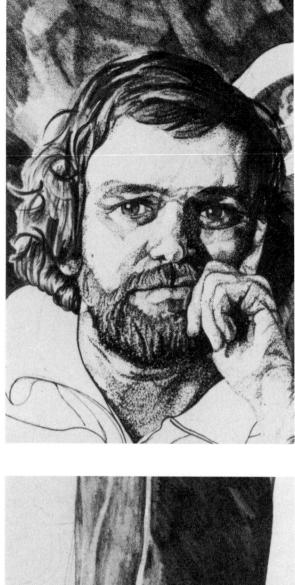

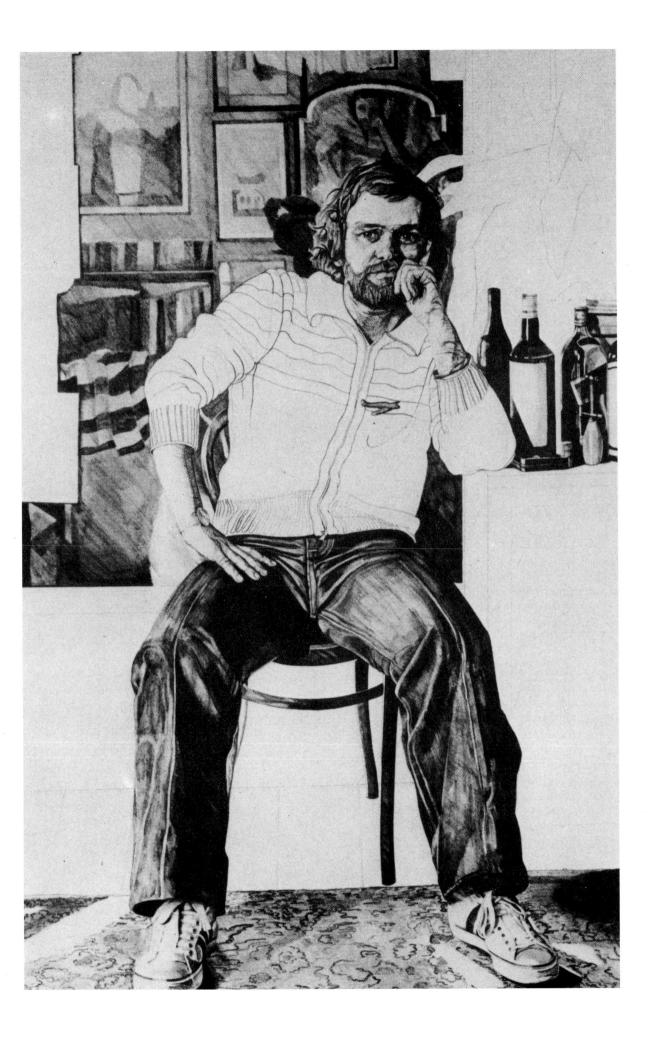

you are trying to interpret a three-dimensional object in two dimensions, and that parts of an object are nearer to you than others, sometimes quite dramatically. This is most evident in life drawing, and *foreshortening*. Imagine a fist extended towards your face; the knuckles of the hand will take up most of the image, and the shoulder at the back will be very insignificant indeed. Sometimes problems will fall away if we remember about perspective, and that *everything* is set in space and is subject to its laws. Even in a still life it is sometimes helpful to put in an eye-line, and insert vanishing points.

There is nothing more rewarding than working away through your own personal drawing problem, but here are some tips to make it easier.

Figure Drawing

It is traditional in old-fashioned teach-yourself books to emphasize that beneath clothing is a nude and beneath the nude is a skeleton, not to mention muscles. There is nothing more offputting than anatomy. As we are not going to draw skeletons, we can take it as read that they are there and influence the shape and movements of the body. The proportions of the various sections are much more useful. A man is eight heads tall, a woman six heads; bearing in mind the fact that we are all different, the half-way point down a man is the crutch or thereabouts. Some professional artists and fashion designers have the women at eight-anda-half heads tall, with longer legs than is natural (or often seen). A one-year-old child is four heads high; a nine-year-old child is six heads tall. Regarding the shape of the torso, that of a man, broad of shoulder and narrow of hip, can be represented by an equilateral triangle upright from a tip, that of a woman by a straightforward triangle. Tricky areas for novices are connecting the head with the shoulders in a convincing manner, the hands and the feet. The neck, unless the head is thrown back, tilts forward; a man's neck slopes slightly outwards, a woman's neck slightly inwards. The neck does not stick on top of the shoulders, but is slightly below. A fist is harder to draw, though there is less of it, than an outstretched hand, and always be aware of the angle and relative smallness of the wrist. You can practise drawing your own hand, preferably with the aid of a mirror. It is far more important to get hands right rather than feet, as feet usually have shoes on. The fingers of a hand are not on the same plane as the thumb unless the hand is fully outstretched. When the hand is held casually the thumb droops. It is very easy for a novice to make a hand look like a flatfish. The main difficulty with feet is getting the

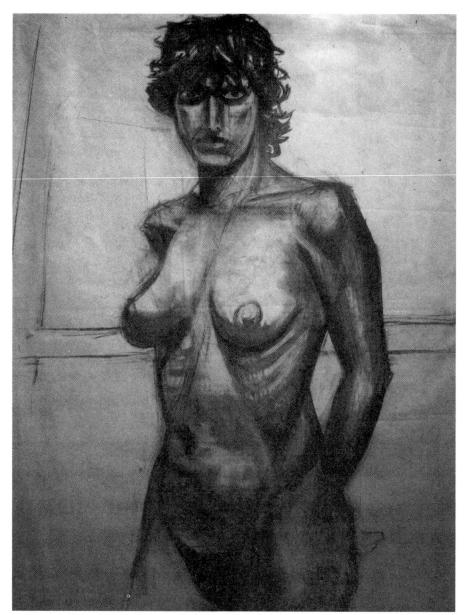

Above: It is important, when drawing the figure, to have an understanding of how the body is formed and how various parts are joined. In this study of a nude, the artist has shown that he understands the underlying forms and clearly defined bone structure. He has used a Conté-type crayon to make this powerful drawing.

Detail of the head.

In complete contrast (to the drawing on the left) this lovely reclining figure has been drawn softly and with tenderness.

Drawing a head in profile can be a most satisfying exercise.

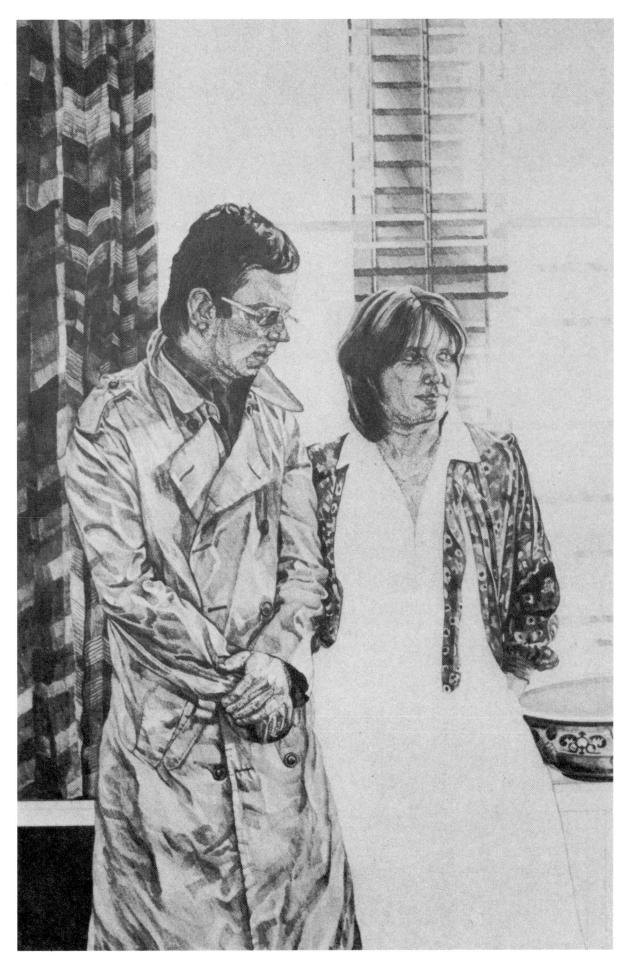

A fully worked study of a couple, taken from a family photograph. The drapes and folds of the clothes have been particularly well drawn. Remember that clothes generally follow the form and should suggest the body beneath. Quick rough sketches can often be just as rewarding as detailed studies. ankle in the right position. If you are drawing a nude you can start where you like, though it is easier to begin somewhere on the torso where there are shadows to give you starting-off points than at the end of a leg. With the torso reasonably accurately drawn it is possible to add the appendages in a convincing manner.

If you have some experience of drawing the nude then it helps when drawing clothed figures. The folds in clothing can be divided into four kinds, occurring in hanging materials, pulled materials, heaped materials and crushed materials. Folds are expressed by shading, but be selective, only putting in those which you think important. Do not be tempted into trying to express pattern or texture in black-andwhite, unless the pattern is very aggressive.

At the life class in art schools it is customary to have a longish session doing one drawing followed by 'quickies', five-minute poses, which can be more enjoyable as you will have no time to quibble over nagging difficulties. These fiveminute studies can best be done with a soft pencil (say 4B) or charcoal, and sometimes even a newcomer can get the pose absolutely right by not thinking about it too much and letting the hand do the work, drawing intuitively rather than intellectually. So if you have completed a drawing which you are really pleased with and want to take it home rather than screw it up and sling it into the nearest waste bucket, what do you do – if it is in charcoal which will partly slide and smudge in transit? You fix it. So when you are using charcoal always keep nearby a can of spray fixative, or a fixative with a diffuser.

If you are using charcoal for a quick nude study it is also worth while keeping some pastels at hand. As with charcoal, you can cover a sheet of cartridge paper in five seconds flat, and for expressing shadow a short length of pastel in a grey or a brown applied on the flat

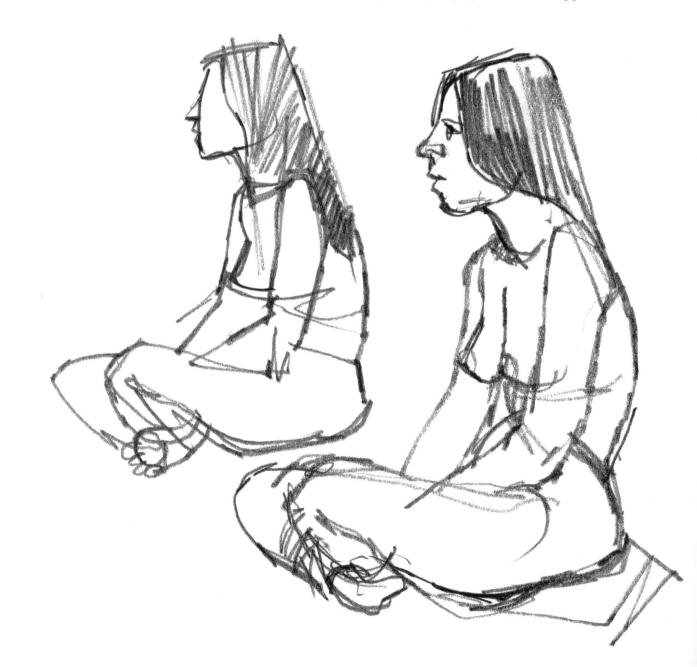

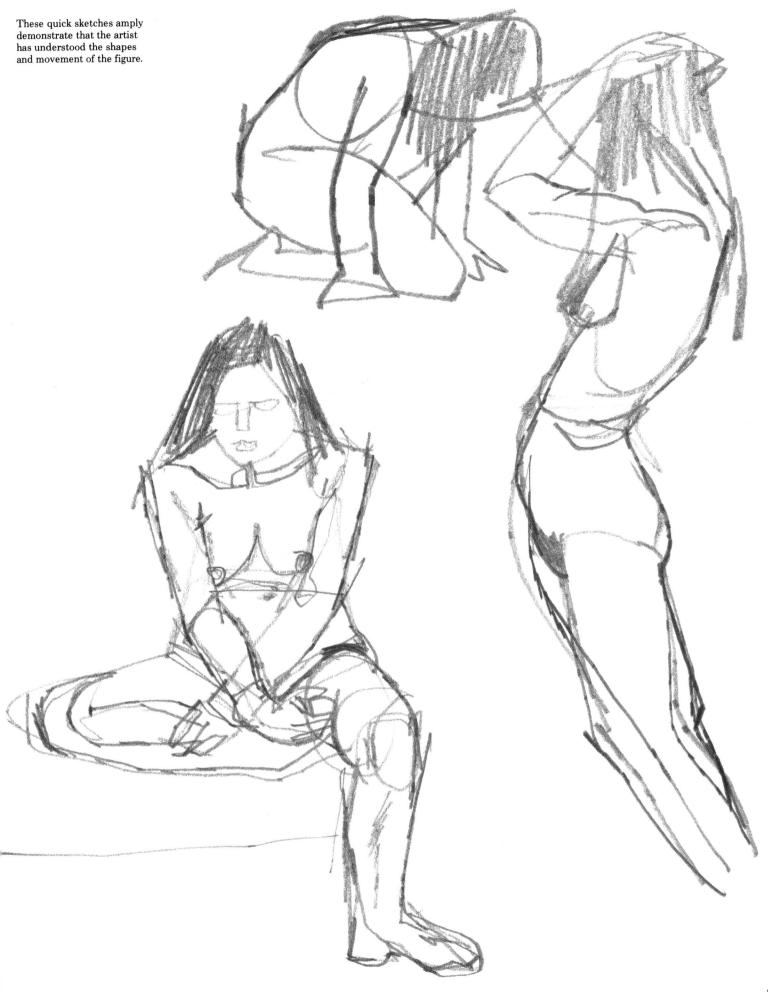

can be perfect. Always remember that it is your choice regarding the medium to use. Sometimes a drawing that started off as a pencil piece demands to be treated with ink.

Always take a variety of different papers with you when drawing nudes or costume studies – cartridge, watercolour, Ingres pastel paper, even brown wrapping paper. You may not use all of them, but they are there if wanted.

Two interesting studies, one in sepia wash and pen, the other in crayon.

Right: Moving figures present a variety of difficulties which can provide a rewarding challenge to overcome.

Below: Detail of the left arm and legs; these are likely to present the most problems but, with close observation, even the most outlandish movements can be set down accurately.

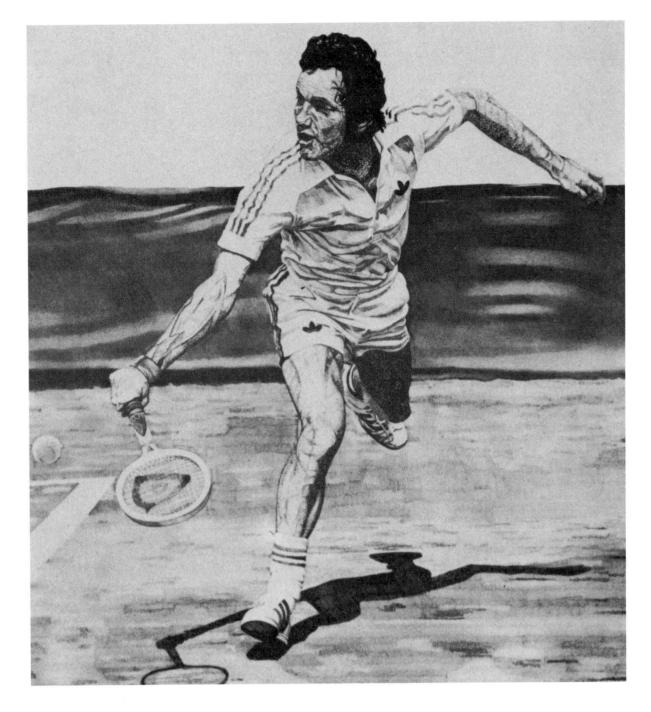

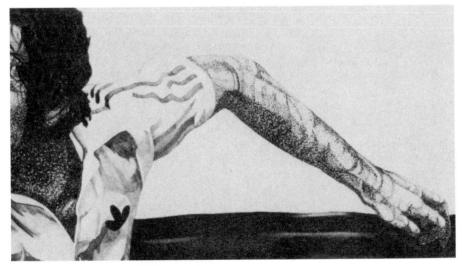

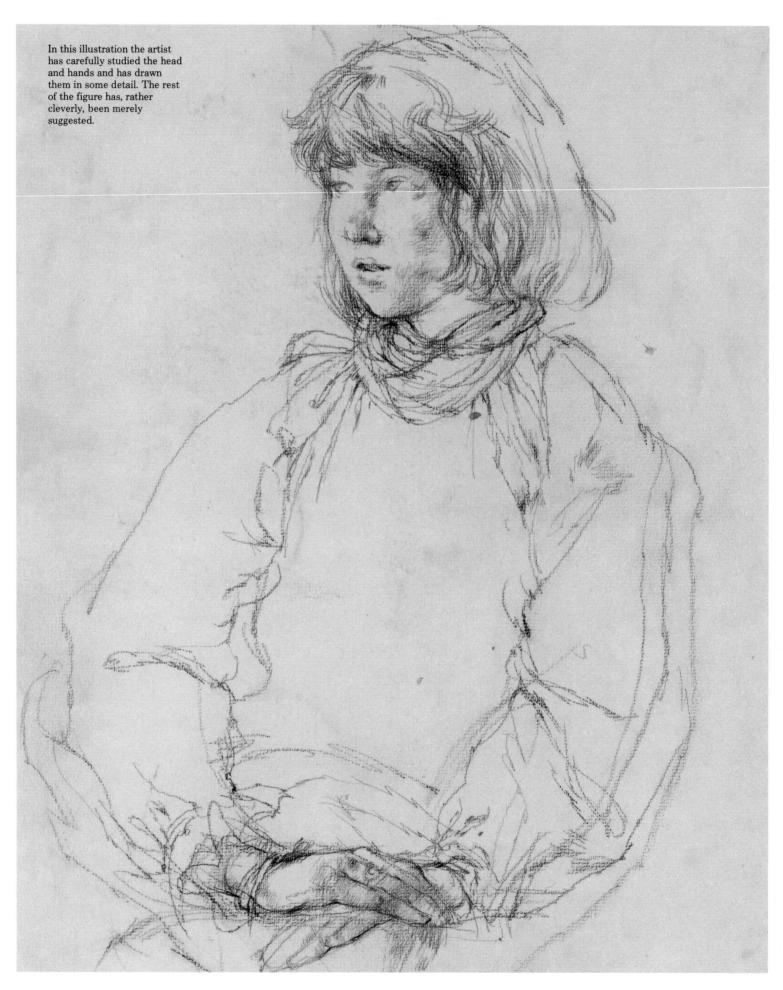

Portrait Drawing

If you think about it, the ability to draw portraits is one of the most highly regarded talents. It is also one of the hardest tests of ability since a portrait, to be of any merit, must be *a likeness*, and there is no harsher critic than your nearest and dearest. Getting a likeness is not as difficult as you might imagine, and there are far fewer problems associated with this branch of art than life drawing – in the first place you do not need to go to a life class; using a mirror you can draw yourself.

What are the first steps?

First of all get your materials together drawing-board, paper pinned on with drawingpins, easel or a chair converted into an easel, an eraser which you may not use, and a pencil or pencils, HB or 2B being the most useful, with an assortment of pastels in reserve if you feel that they are necessary. The best distance for the sitter is about six feet away, the head held at a three-quarter angle, and the light coming from left or right and throwing good shadows. The paper should be level with the sitter's head and the nearer to life size the drawing is the better. If you draw too small you won't be able to see your mistakes. The traditional way is to draw the contour of the head; it doesn't have to be absolutely exact - that can be dealt with later. A dividing line is put in between the hair and the face. Draw a faint line down the middle of the face, and put in three lines, one marking the distance from the hair to the eyebrows, another under the nose, and the other at the bottom of the chin. Then mark in the eyes; the distance between them is usually about the length of an eye. Observe whether the upper lip is long or short and fix in the position of the mouth. Mark the ears. The neck is important; observe the pit in the neck, and how it helps set the head on the shoulders.

Every so often lean back, or get up and take a stroll, so that when you return to the drawing it will say more to you. Continually compare one shape with another, if necessary doodling across the paper with the pencil. When drawing the nose try not to make the nostrils too narrow for otherwise they will appear pinched, and from certain angles the nostrils are not ovals but slits. At all times draw what you are seeing, even if a likeness seems to take a long time in coming, and do not read details into the portrait which you cannot see. For example, when you come to do the ears portray the earhole and the ridges of flesh as they seem, perhaps just as shading, not as scale drawings.

Another method is to start from the eyes, putting these in and working from there, and there are certain proportions that are useful for all methods of approach, the straightforward

Top: Use your colleagues in the office or at work to make a variety of quick sketches.

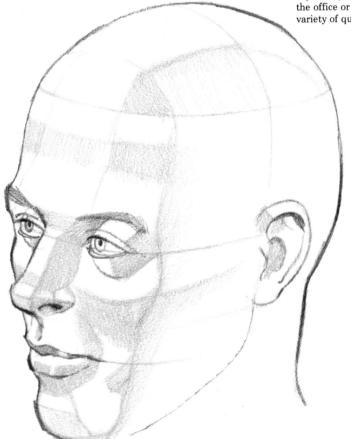

and the oblique.

The eye, conveniently, is situated about halfway down the head, and other useful measurements are these: the distance between the top of the forehead and the top of the nose is approximately the distance between the top of the nose and the bottom. The same distance lies between the top of the upper lip and the bottom

When drawing a head, divide the surface up into contours and planes as illustrated. This is the best method of achieving the correct angle and perspecive.

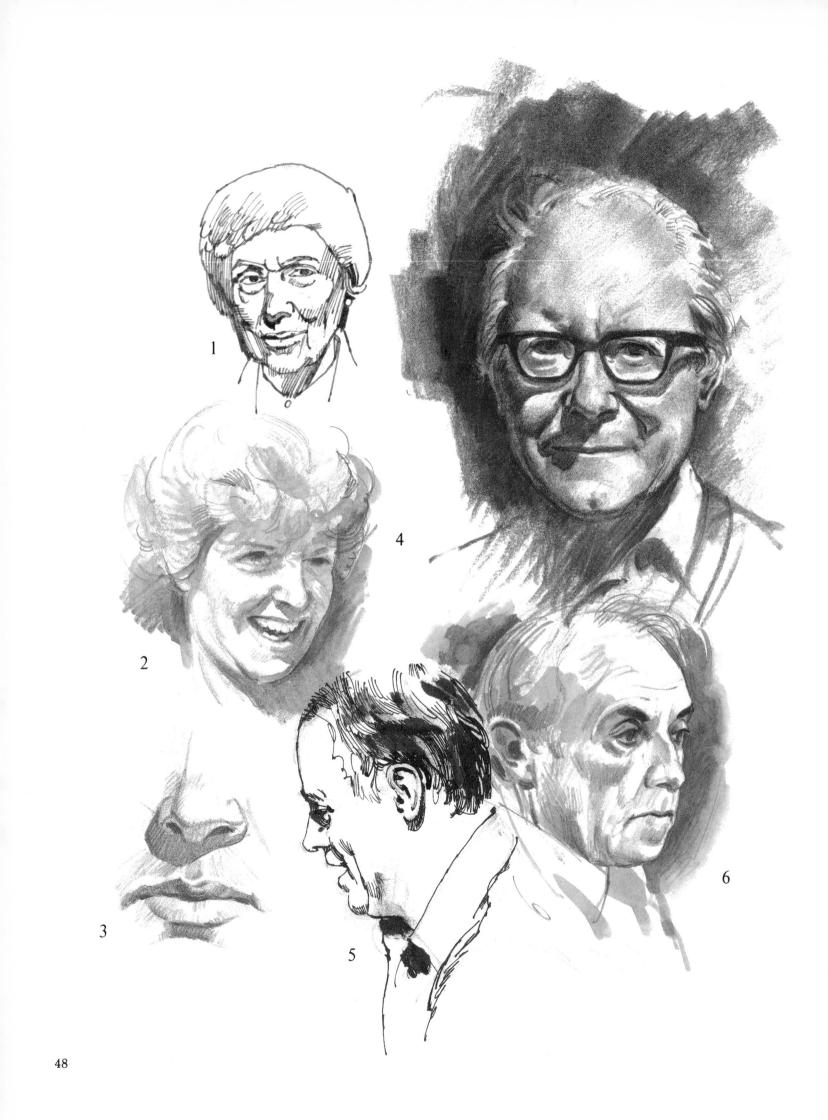

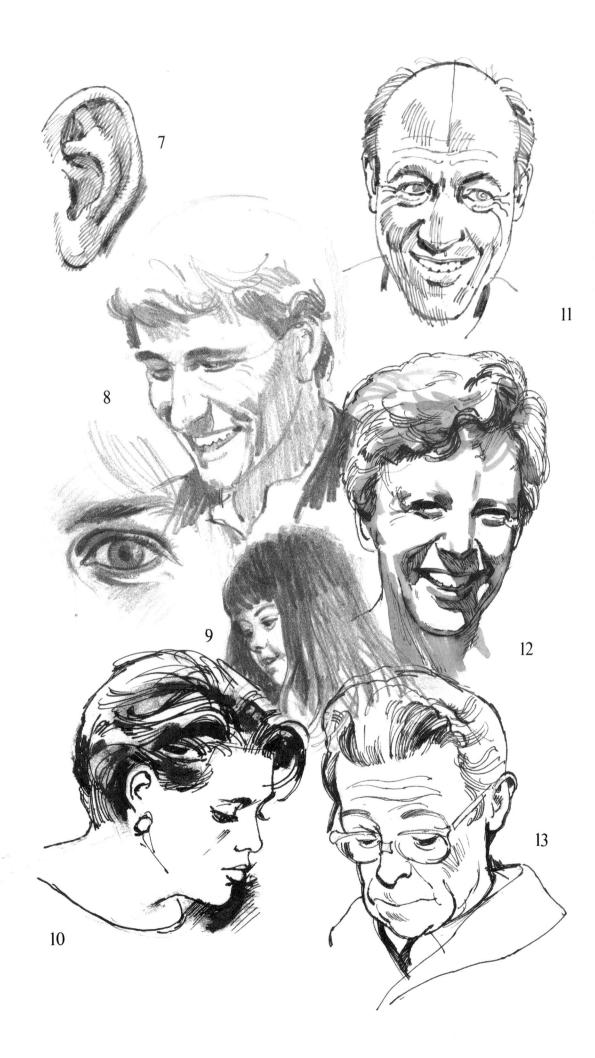

This selection of portraits offers a wide variety of techniques and methods.

- 1. A simple pen-and-ink sketch drawn from life.
- 2. The kind of sketch one can readily make from a photograph.
- 3. A detailed sketch chiselling out various planes and features.
- 4. A direct portrait from life.
- 5. A quick pen sketch with the sitter totally unaware.
- 6. A similar sketch but pencil instead of pen.
- 7. Pen-and-ink is a good medium for studying individual features.
- 8. A light and shade drawing, that can be seen in a magazine, with the detailed rendering of an eye.
- 9. A quick pencil sketch of a child.
- 10. A good expression captured in pen-and-ink.
- 11. This is an obvious, good likeness in pen-and-ink.
- 12. Simple line and tone can give a good effect.
- 13. Features spelt out in an obvious likeness in pen and ink.

The gradual building-up of a portrait, dividing the head into planes, areas and lines.

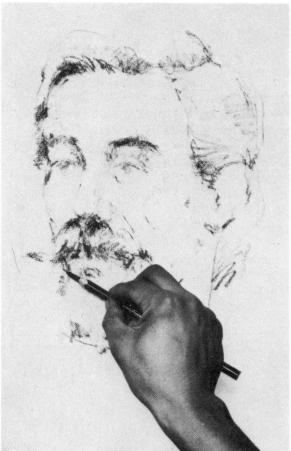

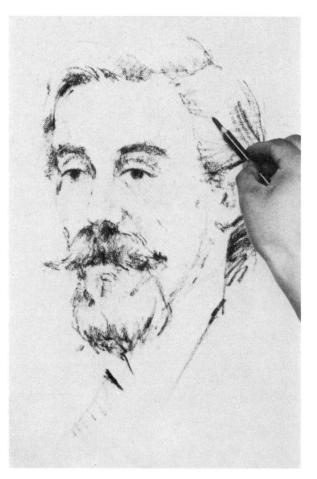

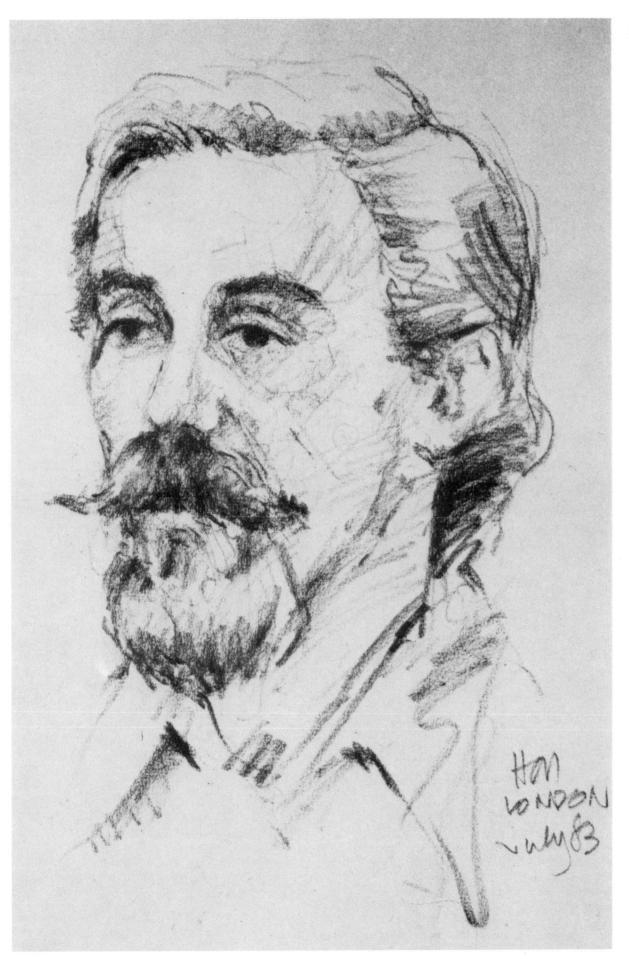

A finished drawing, achieved in approximately ten minutes.

The building-up of a portrait of a girl. In this case the artist began with the mouth and nose and used these as starting-off points; other artists prefer to begin with the eyes and then move on to the nose.

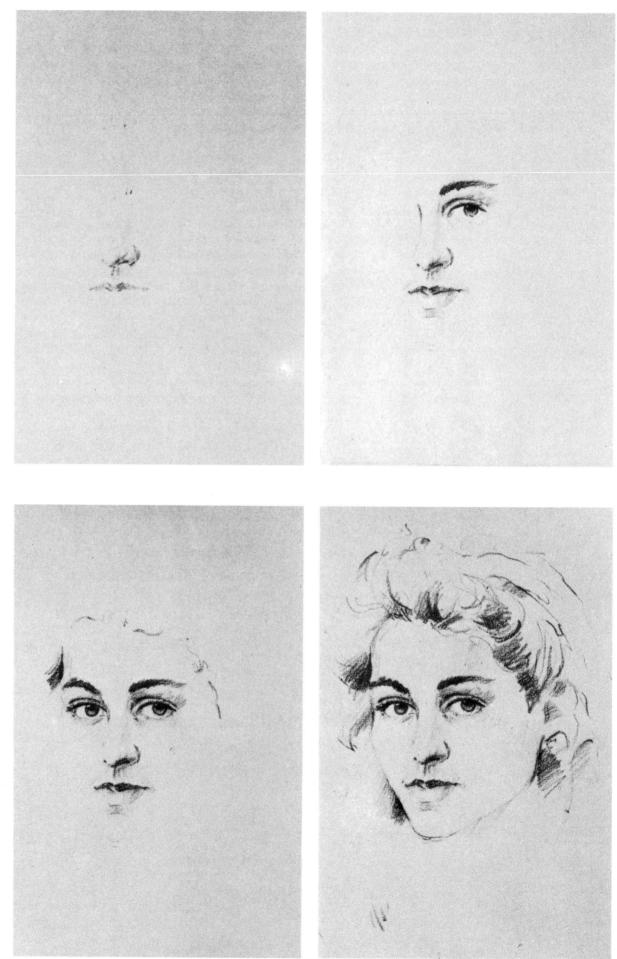

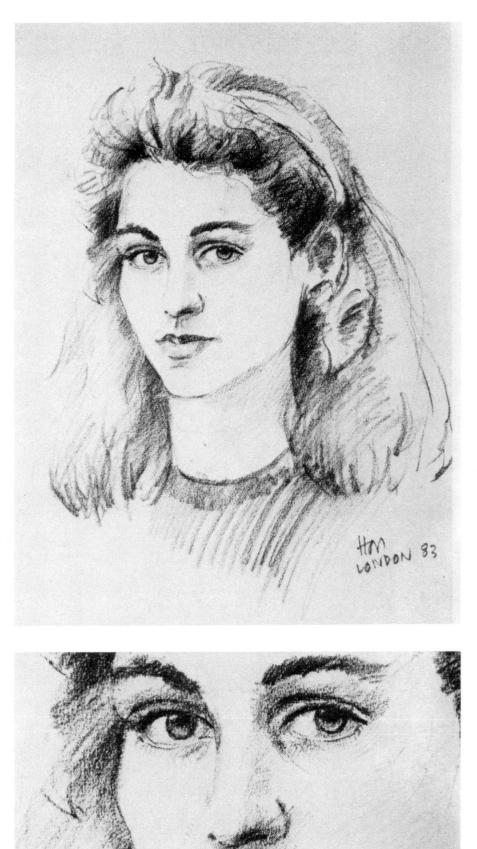

of the chin, and between the top of the ear and the bottom (though ears vary enormously). The top of the ear is on the same level as the eyelid. Newcomers doing a face from memory will simply forget that an eye-unit consists of three parts, the eye itself, the eyebrows and the eyelids. Eyes are the key to a good portrait.

Of course it is not obligatory to start with the eyes. Some artists prefer to begin with background shadows, using these as a guide to the features. This is not a bad idea for newcomers, for shadows are shapes which do not have meanings and there is no temptation to read more into them. Shadow areas can be built up bit by bit with hatching, and this helps when the time comes to put in more determined lines. There are many ways of doing a portrait, and no one best way. The aim is to get a likeness, and a well-drawn face means nothing at all if it is not like the sitter. Of course, the sitter may not like it, but that is a matter for him or her.

The slightest shift of angle will dramatically alter the look of a face, and amateur sitters may find it very difficult to keep the same pose for any length of time. If you are doing a serious portrait, even in pencil or pen-and-ink, it is advisable to use a camera to establish the pose preferably a Polaroid so that it can be referred to and any change of position noted and rectified. The usual pose for a portrait is a three-quarter, which is without doubt easier than a full frontal. With full face there cannot be any divergence between the left and right sides. Profile used to be a very popular position, but the slightest error is noticeable. Uptilted and downtilted heads do not present many problems provided that you look at what you are doing and are aware of the foreshortening.

When drawing a face, try to forget what the individual features are. You are not playing some guessing game. It is easy enough to draw a pair of lips by themselves and get them recognized as such, but in doing a portrait the lower lip may, in certain light, be merely a protrusion with a shadow underneath. There may be nothing to show the lower lip is there; *except* the shadow underneath. Again, the nose may only exist in the form of a shadow.

As you are working only in black and white, you will have to ignore the colour of the hair. Black hair need not necessarily show up as black where the light is on it. The amount of detail in hair depends entirely on you. You obviously cannot put every hair in, but if you wish to suggest hair by a pattern of parallel lines, by all means do so, especially if the rest of the face has been done with attention to detail.

Although it may be difficult to say 'No!' try to

This delightful study successfully captures the warmth and softness of the subject.

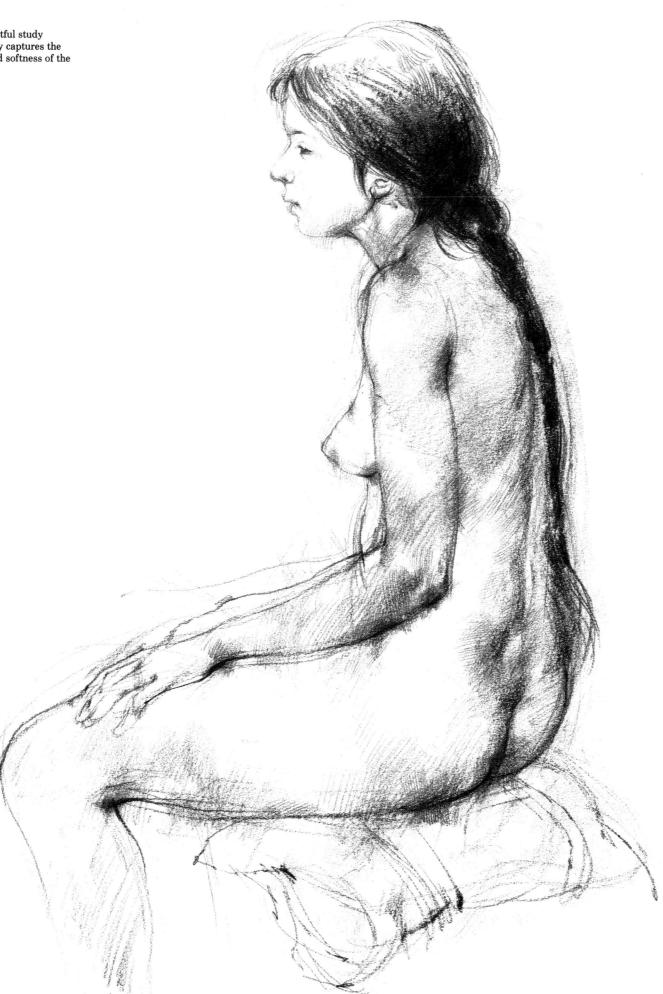

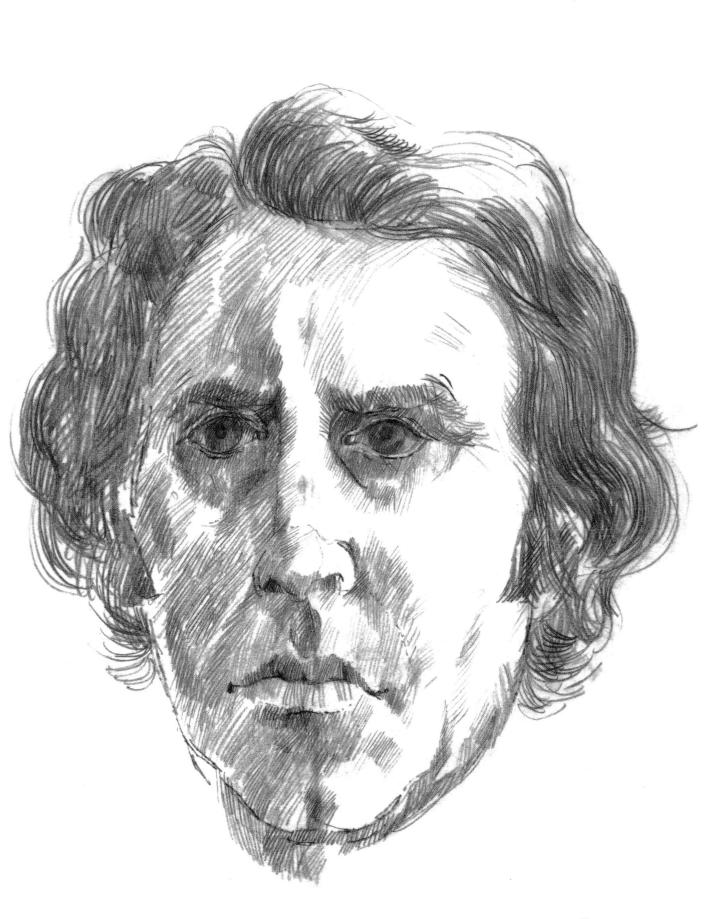

This self-portrait has been quickly executed by an artist in control of his medium.

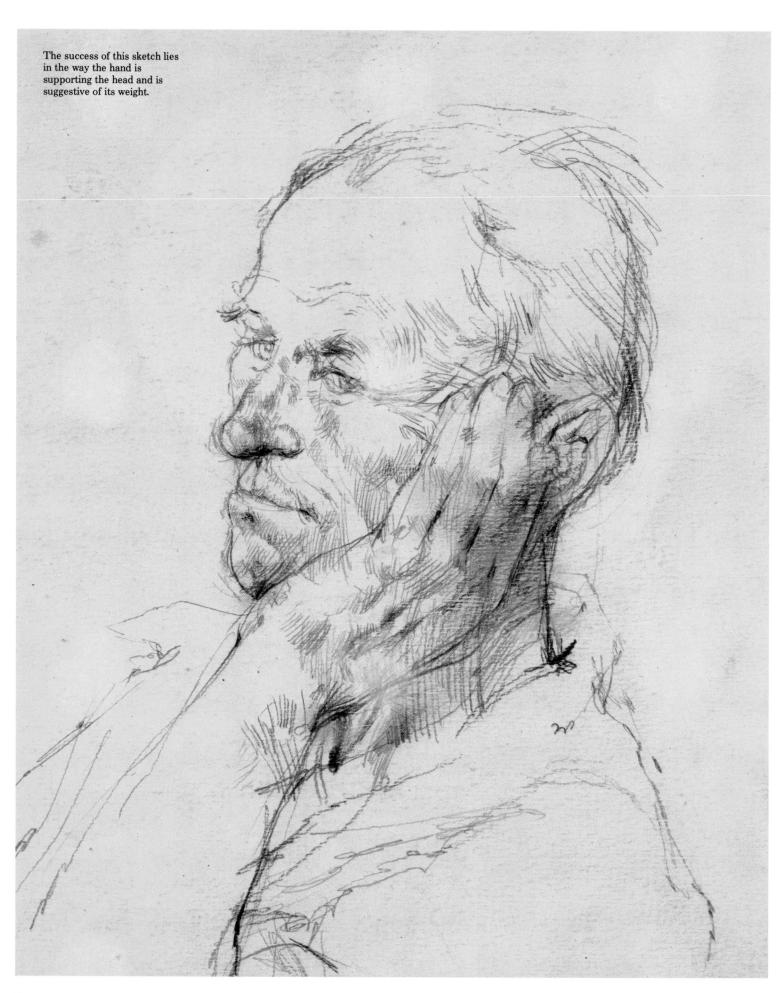

stop a sitter seeing work-in-progress. The merest final touch may make all the difference between a portrait being accurate or not. It might mean just a millimetre added on the pupil of an eye. When it is finished, who judges whether the portrait is 'like'? The famous portraitist William Rothenstein went to Oxford to draw 24 prominent citizens:

'I usually found that each of my sitters thought twenty-three of them excellent likenesses, the twenty-fourth being their own.'

The trials of a professional portrait-painter are illustrated by the fact that when Sir Joshua Reynolds, the first President of the Royal Academy, died, he had on his hands 300 rejected portraits.

Animal Drawing

If you are drawing an animal, even a pet, always remember that at any time it can suddenly move and the odds are against it moving back to exactly the same position. So if you are drawing from life, rapid sketches are more sensible than careful meticulous drawings. Charcoal is ideal for quick work, for you can swiftly brush off with the finger tips lines that are of no use when the animal changes position. Many professional wild-life artists have a collection of stuffed animals and birds (this sometimes shows in their finished work), but you may have to resort to photographs or a natural history museum.

Much that has been said about figure drawing applies to animal drawing. Do not bother too much about how the animal is built up, with skin on flesh and flesh on skeleton. Proportions are vital, but generally speaking animals are Drawing animals can be quite a problem. Practise sketching them as quickly as possible.

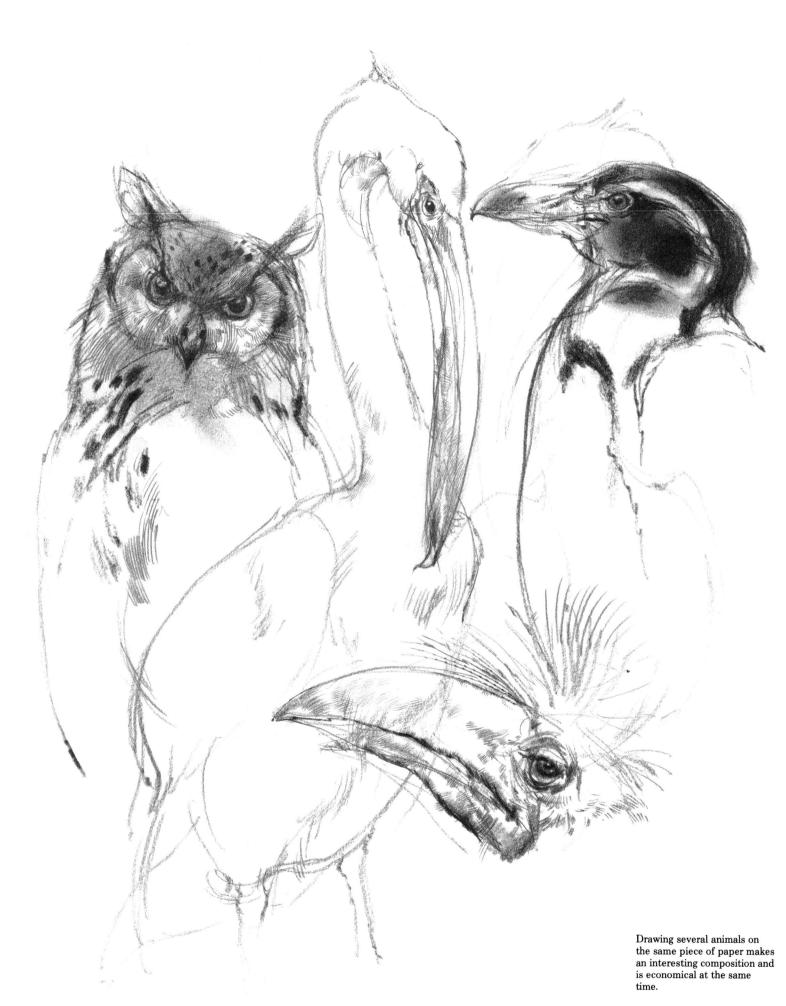

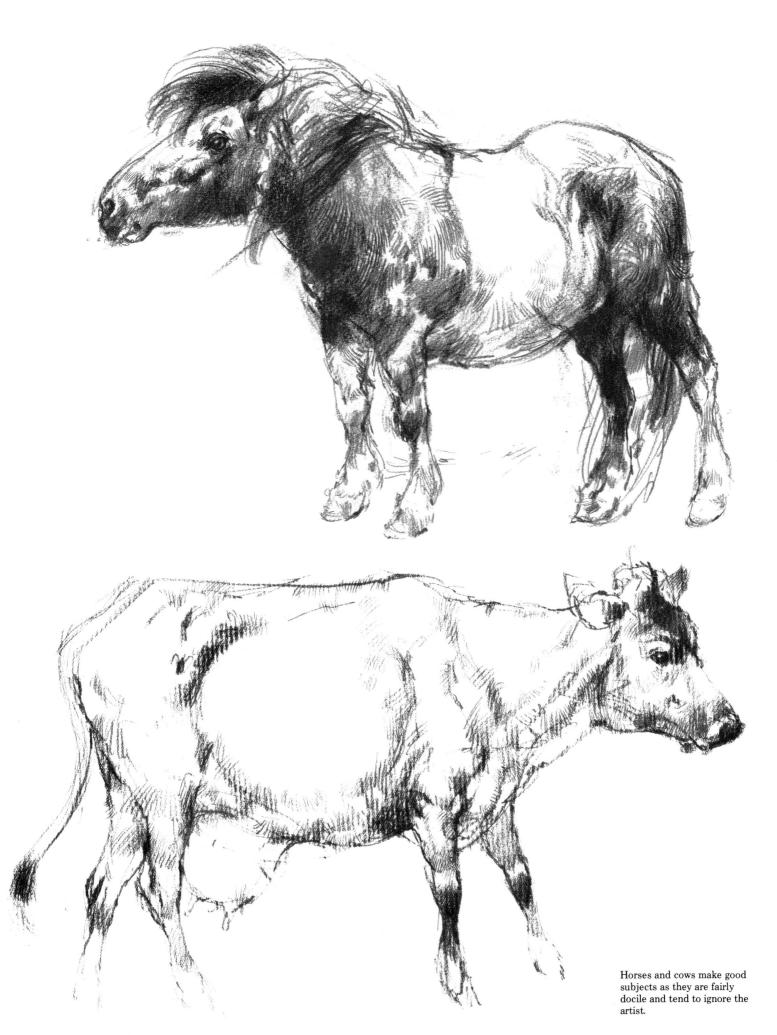

The head of a horse. Most animals have longer necks than one might imagine, but painters of the horse in previous times have shown a tendency to elongate the neck to a ridiculous degree in order to give an impression of speed.

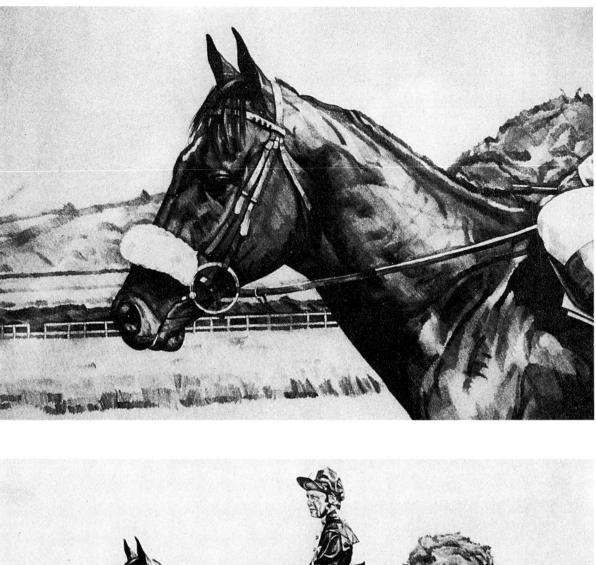

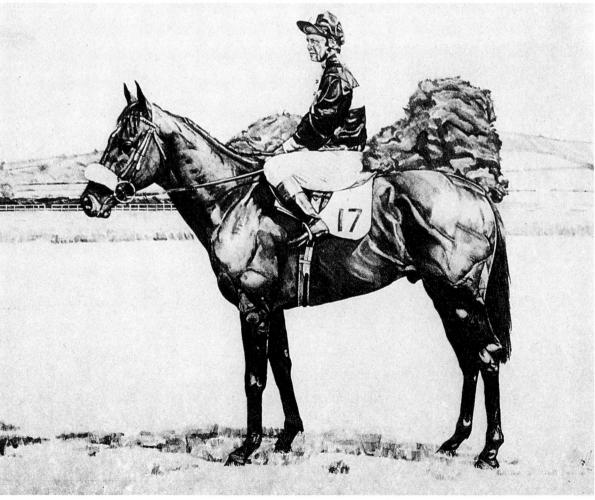

The torso and legs of an animal within a square – well illustrated in this drawing of a horse. easier to draw than human beings because they are more of a piece and have a limited repertoire of actions. For example, cows are either standing up or lying down. They do not lie on their backs, or have one leg in the air, unless there is something wrong with them. The cow is an ideal animal subject for when it moves it moves very slowly and it is chunky and compact. It is easy to relate one shape to another, and as the legs are relatively short it is easier to get them in proportion, whereas a horse has long legs, with consequent difficulty in getting them the right length.

Professional artists have probably drawn more horses than any other animal because it has paid well, and the horse artist, even if not very good, has never been short of commissions. Many 18th-century painters of horses seem never to have looked at a real horse, and persisted in painted horses in gallop with their four legs outstretched at the same time. Eventually photography showed artists that this was not right, but if the early painters had used more observation they would have known the correct sequence of legs. A moral of this is to draw what you see, not what you think is But the 19th-century Frederick there.

Remington and Charles M. Russell, for instance, were notable for their accuracy.

The more compact an animal is, the easier, and an animal in repose makes a more convenient model than one astir. Animals with the same all-over texture are less difficult than those which have a mixture of smooth hair and long hair and rough hair, such as a dog. Novices would do well to start with cats and rabbits.

Draw only those animals which are of interest to you. If you like cats draw cats, if you like dogs draw dogs, and if there are technical problems, struggle with them. To judge by amateur drawings which turn up - not at auctions but at jumble sales, boot sales and the like - more people draw dogs than any other animal, and even if there are faults in the execution the affection shows through. There are certain errors which are repeated in drawing after drawing. The ears are in the wrong place, the back legs don't look right, and there is no animation in the eyes (to avoid this, put in a highlight in the pupil, in the centre so that the dog does not appear cross-eyed). This applies even if, when drawing the dog, there does not appear to be any highlight. With drawing cats, the main difficulty seems to be the nose and

Here the artist has immortalized his favourite pet.

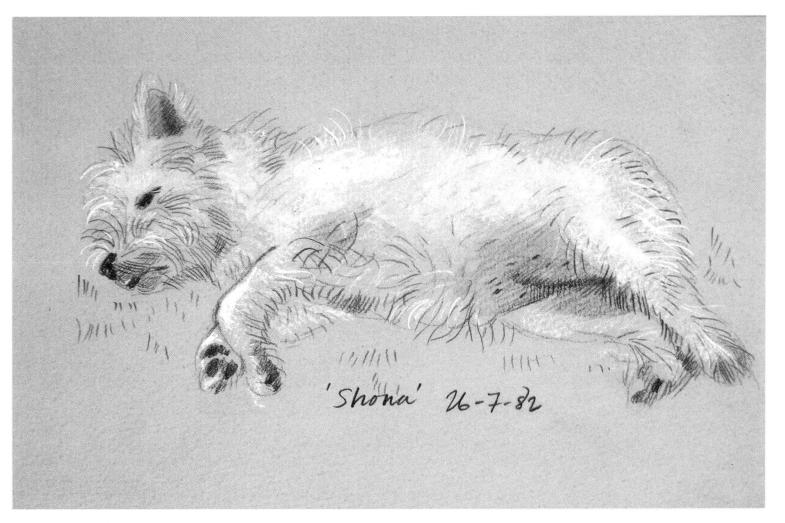

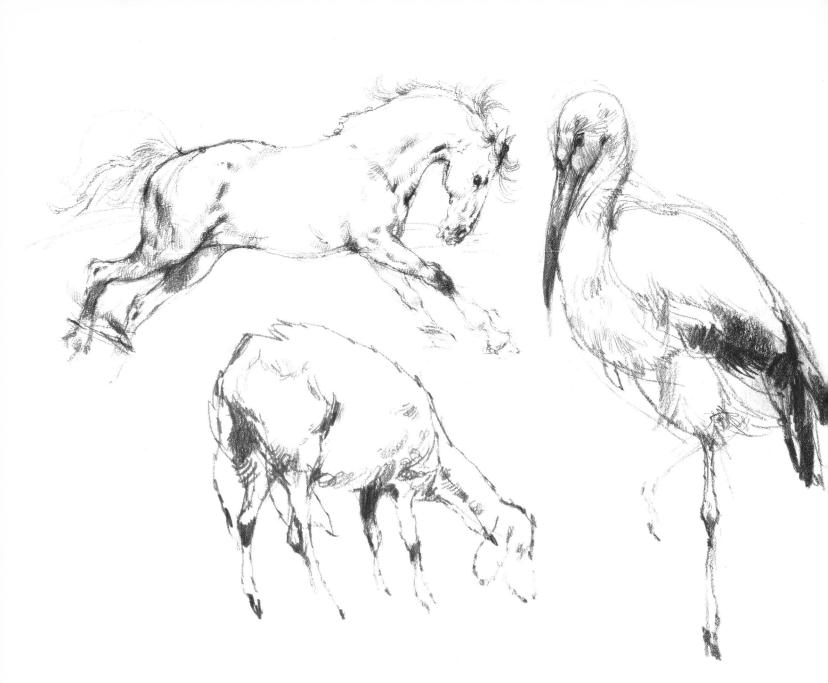

That most essential ingredient, movement, has been convincingly demonstrated in these various animals. the nostrils and in indicating the mouth without having the cat grinning. The coat of a cat is easier to draw than that of a dog as it 'flows' in a more consistent way.

The men who drew the most lively and realistic dogs and cats were not the high-flying painters of the academies but the cartoonists of magazines such as *Punch* in the 19th century, with its Charles Keene and John Leech. Bound volumes are in libraries and for sale secondhand and it is worthwhile looking at them and discovering how animals should be drawn.

It is often overlooked when drawing animals from memory that they have necks, and that the legs are set further back than you would imagine. A useful guide-line is that in many animals, and in most of the familiar ones such as cows, horses and dogs, the distance from the front of the forelegs to the back of the rear legs is the same as the distance from the ground to the top of the body. In other words, the torso and legs of a standing animal are contained in a perfect square. If there is any part of an animal that presents difficulties, it is the leg, especially the back leg. The curious shape of a dog's back legs is obvious, but those of other animals are not so straightforward as you might remember. When drawing animals in herds, it is not usually necessary to make a study of each of them. This is more apparent in paintings, where sheep (simple animals to draw) are often represented by landscapists as blobs with a bit of black at one end and four sticks as legs.

Birds are delightful to draw because they have so few component parts, and it is not difficult to relate wing length to body length. There is however little point in trying to draw them in real life. The wild-life programmes on television are a boon to bird artists, as they are to all wild-life painters, giving close-ups we would never experience otherwise.

The main problem with drawing birds lies in depicting the feathers. These are not fixed on in a haphazard manner but have a structure.

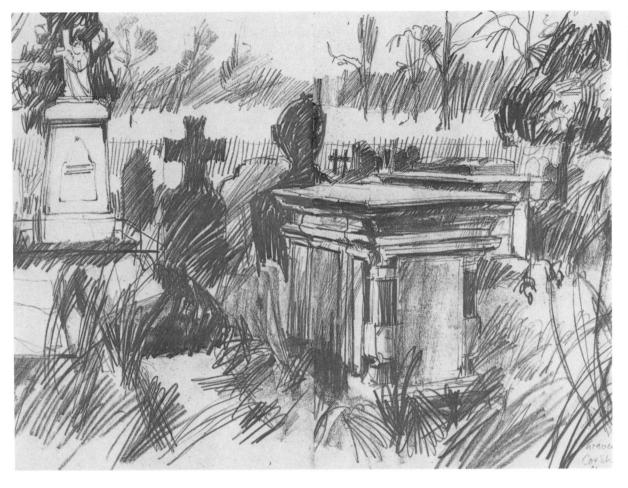

An atmospheric drawing of a graveyard. There is a brooding quality of neglect suggested by the overgrown foliage, which has been strongly suggested through the use of pencil work.

The simplest way to describe this is that the feathers occur in overlapping segments of feather batches, each of which throws shadows on to those lying beneath it. The feathers of the tail lying over and shadowing the body can be seen clearly. The legs of a bird are very slender indeed, and when the bird is on the ground it is very tempting to draw the legs when in fact they cannot be seen.

Perhaps the easiest creatures to draw are mice, hamsters and jerbils and similar small animals. There are several reasons for this. One is that they can be taken in with one glance and it is simple to relate one part of the body to another. Two, their legs are small and partly hidden so that it is difficult to get them out of proportion, and three, the coat is usually of a consistent texture.

Landscape

Landscape-drawing and painting are among the great pleasures of life, even for those who are just setting out on their artistic career, whether 16 or 60. It is easy to get dewy-eyed on the subject of nature, and we tend to take it for granted, along with Wordsworth and his daffodils. We may look at nature at its most spectacular if we are told to in a guide-book, but too often it is something we pass by.

Nature does not move very much, so you can spend as much or as little time drawing one subject as you wish. However, the lighting does change, often dramatically, though this is of more concern to painters than to those who are just using a pencil or pen-and-ink. Shadows change gradually with the passing hours, and not too quickly to put down. Once again it is important that a house is not seen as a rectangle with four squares in it for windows, but as a pattern of light and shade. Remember what you are looking at and forget what it is, and watch for groupings. Draw something interesting to you, not something which you feel is a right and proper subject for the Artistic with a capital A. If you like bungalows, draw bungalows rather than the local church. If ordinary landscape bores you, stick to the town - many famous artists have built up their reputations from their pictures of the suburbs.

As with all kinds of art, you have a multitude of choices, not only with the particular view you have selected out of countless options, but whether you decide to do it 'straight' or refine it. In other words, making a composition.

The first thing to do after you have settled down, whether you are sitting on a convenient bench with your sketchbook in hand, or standing in front of an easel, or sitting at your car Pylons and power stations always provide interesting shapes to draw. Rather than try to draw each individual line and cable, the artist has selected the main features and his loose approach gives the feel of the massive complexity of the installation.

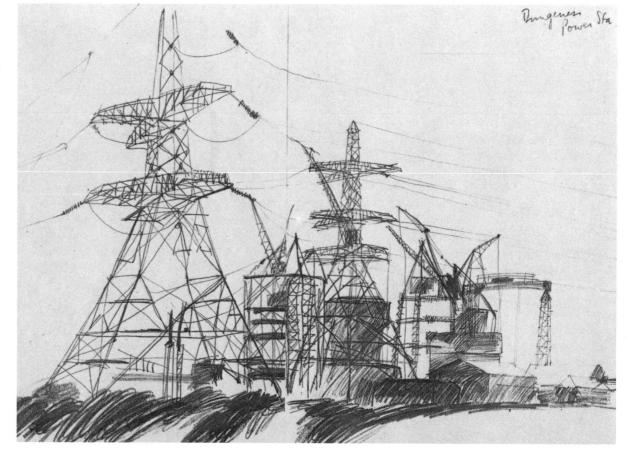

window, is to draw the horizon and the eyelevel. You must bear in mind perspective, and remember that all things above the eye-level lead down to the horizon and all things below lead up. The horizon may be obscured by hills or trees, but that does not matter. A pencil held up at arm's length in line with the eye will give you the horizon. Do not change position halfway through a drawing, as this will alter your eye-level.

Everything which reaches the eye is really of the same importance. Do not pick out the features which seem of most concern and emphasize them unduly, keep windows and doors the right size and do not go overboard on detail, unless that happens to be your style. If you want to count the layers of brick on a building, by all means do so, but there will be more than you think, and painstakingly putting in every single brick can be tiresome. Too much detail on the light part of a drawing can counteract the shading. If there is detail, the foreground is the best place to put it, and do not *imagine* detail in the middle distance or far distance.

Trees are most likely to be a stumbling block in a simple country view, and it is very easy to make them symmetrical. Mostly they are not.

Right: In complete contrast to the illustration above, the eye level is above the subject.

Every artist has an individual way of doing trees, but very few of them past or present put on every leaf. A suggestion of leafiness is the main thing. The basic shape of the tree is best seen in winter when except for evergreens they are leafless, and the way the branches go is often very interesting. The variety of leafage on a tree is not, as often depicted, expressed in a change of colour, but in light and shade. Leaves usually grow in masses, each of which has a light and dark part, and the shadow of which will fall on some other group of leaves. It is important to make the tree seem solid. The trunks are much simpler to do than the leaves. and the characteristics of the various kinds of tree can be demonstrated with shading. A tree is one of the few landscape objects where shadows do alter dramatically, and too much time spent drawing-in infinite detail is time wasted. The shadows and the entire disposition of light and shade will have altered by the time the drawing is completed.

Bushes should be looked at closely, for the changes of tone need not be dramatic. Halfclose the eyes and try to compare the various tones inside the bush. If the bush is in the foreground you may find yourself looking into it from above. Sometimes the bottom of the bush in deep shadow is enlivened by grass and plants which are in the light, and these silhouette themselves against the shadows. These can be depicted in drawings by taking an eraser and, holding it by the edge, 'drawing' in the blades of grass with a corner of the eraser, lining in the shade of the blade of grass with a precise pencil line. Hedgerows are very good to have in the distance or middle distance, as they can be used to define fields and establish relative sizes of features such as barns and cottages.

If you are going to use trees or tree parts in the foreground it is not a bad idea to collect a few typical branches and take them home and draw them, but do not pick any wild plants. Expanses of grass can be a minor difficulty. Except in the immediate foreground individual blades of grass are not seen, and can be best registered with shading. Tufts have a shaded side, and cast shadows on to the ground. In the middle distance grass can best be represented by grading the tone as the surface of the ground rises and drops. The ground itself is important, and by the use of shading you have to specify which way it is going, whether it is tilted, what happens when it dips. Whereas in much landscape detail we have to forget what we know in order to see accurately, when we are dealing with the surface on which all the features are positioned the only way we know which way the ground is going is by the light and shade.

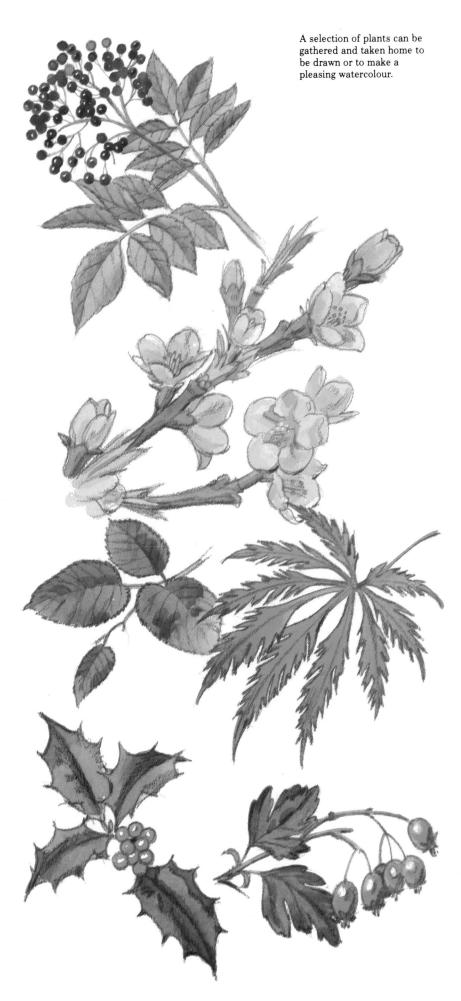

Landscapes, like townscapes, naturally involve all the problems of perspective, both linear and aerial.

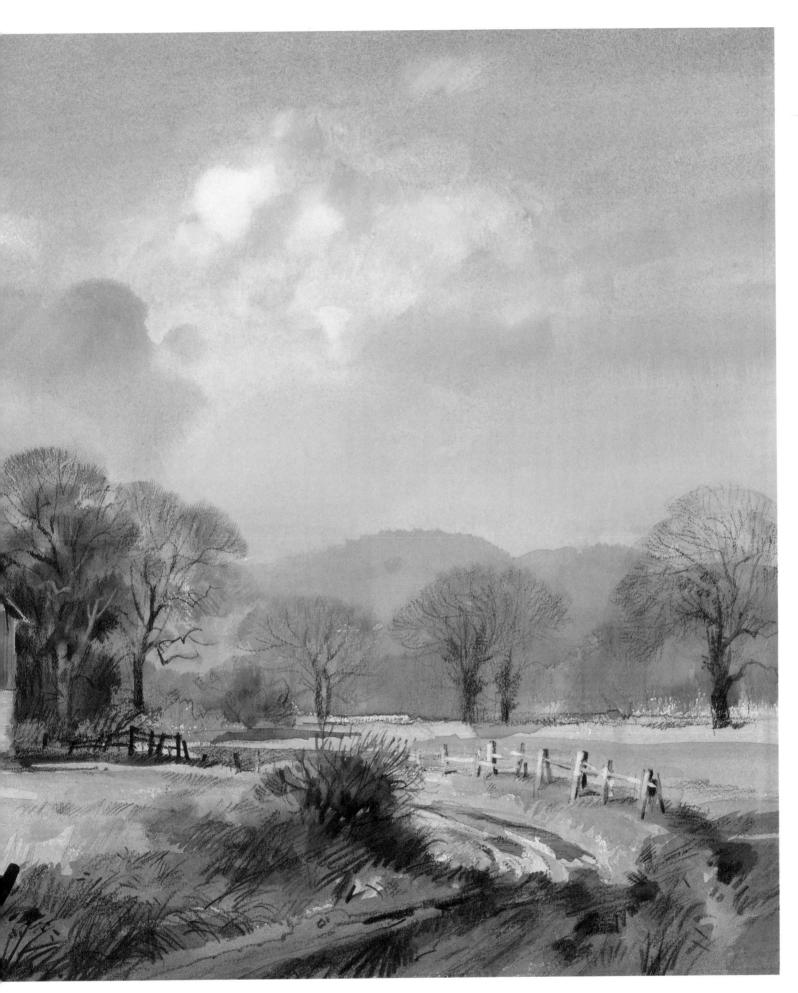

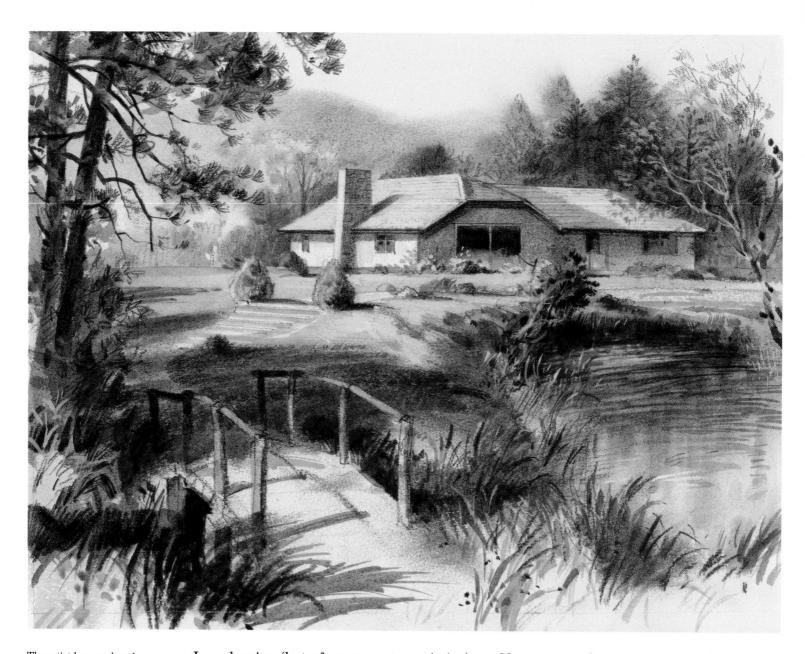

The artist has employed a variety of techniques to produce this delightful drawing. Note the use of white paint to raise the highlights out of the cream-tone background. In a drawing (but of course not a painting) the sky and the clouds are of minor importance, and if clouds are put in they should be put in lightly as otherwise their presence will overwhelm what is happening on the ground below. Water in a landscape is always a plus, and the reflections in water can add great interest to a picture. It is necessary to really *look* at reflections, and not put in replicas of what is above the water level. Rippling water makes nonsense of mirror images. There is a weird sort of perspective in reflections, and there is also the question of refraction, in which the reflections do not make sense. It is important to look and digest.

It is very easy to make a stream or brook look like a path, and even when using a watercolour it does not help to paint it blue. Sometimes a stream needs to be suggested, its existence noted with waterside reeds, so that the viewer picks up the clues.

No matter where you go, always take a sketch-book with you. Those with a spiral back are the best, and the small postcard size will get you into the habit of making thumbnail sketches. Draw anything that appeals to you, even if it might seem outside your technical ability. If you are going out, work out the potential sketching possibilities - a cup of coffee in a place where there are secluded side seats and nooks and crannies so that you can sketch without someone peering over your shoulder, a country car-trip where there are parking places convenient to good sketching territory, a visit to a friend's house where there are good roof-top views from a convenient window and there may be interesting subjects to look down on. Even if you feel the sketches are failures, do not throw them away. At the very least they will be an indication in the future of your progress. And everybody gets more proficient, never less.

Townscape

Most books on practical painting do not mention townscape, which is a pity because it offers much to those who live in towns and who find the countryside somewhat alien. Although it does not always do to generalize, a townscape is usually simpler to draw and paint than a landscape, especially for those who have come to grips with perspective. You are also not diverted from looking for the differences in light and shade by too much colour. Townscapes can merge into landscapes, but the gaunt industrial towns of the north have their own kind of sombre beauty and even, as in the paintings of L. S. Lowry, a wistful charm. Many of the recommendations for country drawing apply to townscapes – do not let the detail in the middle distance get out of hand, draw when there are interesting shadow-shapes about, let the features stand out for themselves and do not over-emphasize important features. Sometimes a townscape looks odd without figures, and although this will not matter much in a drawing which is meant to represent what you are seeing, if the drawing is worked up into a painting, figures – inserted according to the rules of perspective – do add interest to a townscape. No need to go mad with them, as Lowry did. They also serve as splashes of colour in paintings, and are useful for setting

The people and traffic are mere suggestions in this sketch, but the bustle of the street is well captured and contrasts well with the grandeur of the building behind.

This interesting perspective drawing (*right*) has the front of the car below eye level, with buildings receding dramatically in the background. the scale of the adjacent buildings and other features. As with traditional landscape, water adds interest; in townscapes it is usually a river or a canal. Many of today's canals are derelict and consequently picturesque – and usually situated in the inner suburbs and run-down areas. What with traffic and hordes of people, it is often advisable to carry a camera with you when searching for townscapes.

When you are adding figures to a landscape or a townscape, always remember that they have shadows which must go the same way as those already in the picture. Shadows can be useful if you are putting in groups of people, and cast shadows, where one person is standing obscuring or partly obscuring a neighbour, can depict figures as certainly as line. Look on

groups of people not as a collection of distinct individuals but as a tonal block - adjoining rectangular shapes with protrusions on top (the heads). Legs are less evident in groups of people, especially if there are strong shadows. For townscapes to be really believable, they need to contain objects we take for granted and hardly notice are there, for example, cars, moving and parked. As with figures, they often add colour to a picture or an accent in an otherwise empty spot, but if you draw a car from memory you will find it an odd experience. You will probably over-emphasize the upper part of the car, which is actually little more than a glass box on top of the solid bodywork. The wheels also pose a problem; how much is hidden under the wings? You need to look at

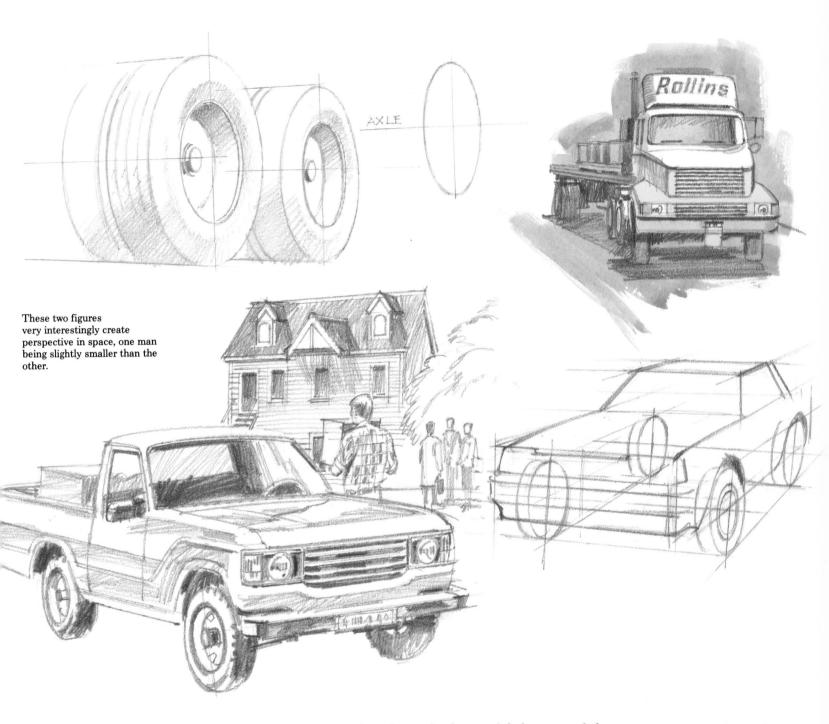

cars or at photographs of them.

When drawing cars, shadows are very important, for if there is any light at all the area beneath the wings and the car itself will be in dense shadow. Although it does not matter so much in drawing, the metal of the car will throw off highlights, and in paintings these highlights can be employed very effectively. Drawing cars is a good way of getting to know how to draw other mechanical objects, and coming to terms with circular objects which turn into ellipses as they turn away from us or to us. Whether the angle of the ellipse is *exactly* right is of less importance than the need to keep it symmetrical, and not have odd bulges on one side. By all means use aids to get your wheels right. Stationers keep a stock of stencils of various sized circles and other useful shapes, and these stencils can also be used for ellipses by tracing down one side, and then the other, leaving out the section in the middle and joining the two arcs together by freehand. It will not be a perfect ellipse, but it should prove convincing enough and that is the object of it all - what looks right, is right. If you are putting imaginary cars into a townscape, or, for that matter, a landscape, work out whether the windows will look transparent or opaque. One of the main points to remember about cars is that they are not very high; a man of reasonable height can stand by a car and rest his elbows on the roof. So in a street scene with pedestrians and traffic, pedestrians' heads will always appear well above the roofs of the cars.

Practise drawing wheels and perspective lines on vehicles.

Still Life

A drawing of a landscape, townscape, portrait or figure will often stand by itself as a work of art. A still life rarely does. Still-life drawings are usually used as a basis for a painting or as an exercise, and even the most accomplished stilllife drawing is not intrinsically interesting. The one great advantage of still life is that you are in control of the composition, arranging the lighting as you want it, getting the shadows you like, and grouping the objects in the most acceptable manner.

Naturally you collect what objects you want when setting up a still life, and although fruit and jugs are the obvious things to select they can be impersonal. So why not build up a still life with objects which have some connection with you, have pleasant associations, or present some interesting but not insoluble problem? It can be anything from a small statuette, a seaside ornament, to a book. A book is an ideal thing to draw because it is symmetrical and can act as a perspective guide to other items in the assemblage.

It is good not only to have a variety of shapes but a variety of textures as well, so drape some material around, letting it partly obscure some of the objects. The items do not have to be in the middle of the picture, nor do they have to be piled in a heap all at the same distance from the artist. Something placed in the foreground will make a picture more interesting.

When drawing the various objects which surround you, try to suggest their intrinsic qualities of hardness, softness and texture with the use of tone.

Exactly the same objects as before but arranged in a rather more pleasing composition. Let the eye roam around the still life, examining the possibility of turning it into an interior drawing. Look at the window, which may be your light source; notice how it is much darker in the area immediately around the window frame. Where there are deep shadows, put them in in deep black, using charcoal or Conté crayon, smudging with the finger tip if you like.

Flower painting comes into the general area of still life, if the flowers are set in a vase or a bowl on a table. They are not in their natural habitat, and can be manipulated as desired. Flowers demand colour, and perhaps pencil is the least suitable medium except as a try-yourskill exercise. Unlike many other objects in nature, there is a change of colour in flowers and not just tone, and when doing a drawing it is important to decide what is happening. In flowers there are many varieties of shadows, and although the drawing of petals and leaves presents few problems in itself, these petals and leaves cast shadows on other petals and leaves, and so on and so on. So before even putting pencil to paper it is necessary to study such shadows, moving the light source around and seeing the result.

Some flowers are easier to draw than others. Those with a multitude of small shapes such as a hyacinth are more difficult than flowers with a fully comprehensible structure such as a rose.

Quick washes laid down as above can be brought to life with pen and ink.

Seascape

Much of what has been said about landscapes applies to seascapes and, if anything, seascapes are easier, provided you put the horizon in *exactly* the horizontal position – otherwise the sea will appear to be slipping downhill. Ships are fine subjects for drawing, but it is best to get them right, for it is incredible how many people know about ships and which way the sails should go and why that mast is two metres (or should it be a furlong?) too tall. In a landscape, it does not matter if the tree is the wrong shape; in boats it does.

Boats are usually entities in themselves and, unlike some landscape features, they make sense, and can be summed up at a glance. Boats in the foreground or tied up together at a quay can also be figured out, even though you may not know what all the ropes are for. The shadows on boats are also comprehensible; if the shadow is on one side of the boat, it will apply to *all* that side and, as the superstructure is usually in one block, cast shadows are not much of a problem. Do not get bogged down with all the ropes and lines unless you are doing a very detailed drawing.

Seascapes are usually more interesting if there is subject matter in the foreground (even if it is only a few rocks or an extra-special wave). Painters of the old school often put in a red marker buoy to add interest to the foreground.

It is often an advantage to have an indication of land in the distance. This will rest on the

All the ingredients of the sketch (*above*) can be practised before arriving at the final picture.

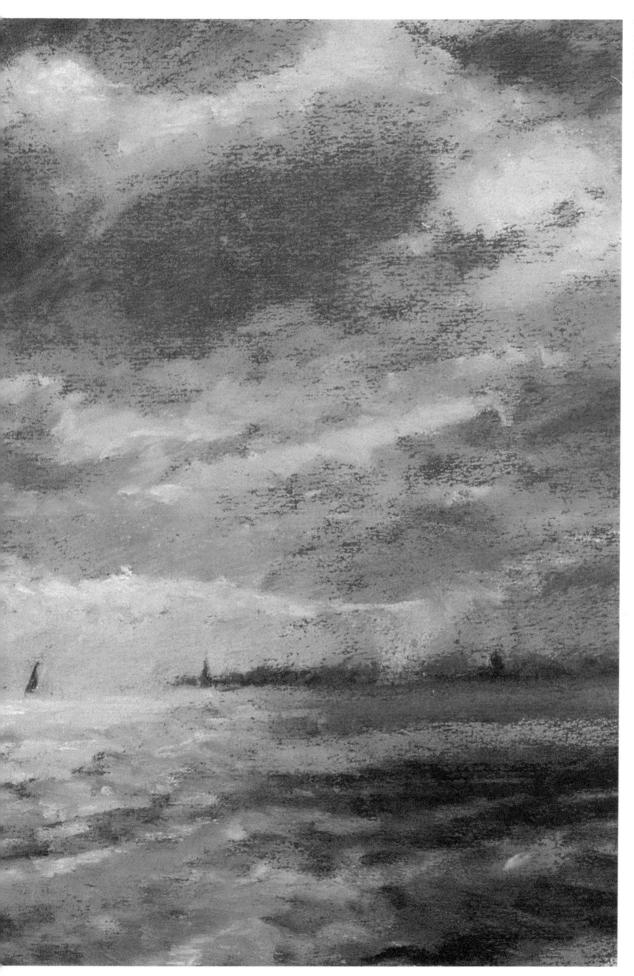

This pleasing seascape can be finished off at home provided you have remembered to make on-the-spot visual references in your sketchbook. horizon, not intrude into the sea-space unless it is in the middle distance.

If you are trying to do waves in pencil you are tempting providence; it is sufficient to get the *feel* of waves, and not be precise. Waves are good for painting, but not for pencil work, and seascapes in pencil can never be really convincing. They should be regarded as sketches for paintings. Seascapes are among the most enjoyable type of pictures to do.

It is very restful to look at the sea, and if you have a seascape in mind remember how waves react, how they form and break, and how, very important, they fit into a pattern of other waves and water movement. The *look* of the sea is far more significant than the accuracy of the odd wave. Nowhere is reference to photographs of other artists' work so useful as in depicting the sea; everyone has their own method. The Venetians such as Canaletto used an unconvincing pattern of flat U-shapes, but others have done really convincing seas, even quite minor artists now almost forgotten. Photographs of seas are useful but not as much as photographs of other artists' endeavours, who somehow had to express the constantly moving. Television and video are enormous helps in letting us see, via the freeze frame in video, exactly what water in motion looks like.

Waves, too, obey the laws of perspective, and recede according to the rules; they also have shadows, but judging by the blobs of blue and green in the paintings of real novices they are often forgotten.

Right: There is no perspective in the sea. Waves become smaller and eventually disappear on the horizon. This can be seen in the Turner seascape (below): Calais Pier: An English Packet Arriving.

PICTURE MAKING

It is easy to get preoccupied with the various kinds of paints, watercolours, oils, acrylic, pastels and other materials and think they are divided into exclusive compartments. They do require different equipment, but if divisions are to be made there are just two – paints which go with water and paints which go with oils. However, even this division is not sacred. For example, the sculptor Henry Moore used oil pastels and watercolours for his drawings, which do not mix. That is why he used them. His aim was to make the oil-pastel drawing stand out from the background, so he used the oil pastel first for his main features and then covered the paper with a watercolour wash, which, being repelled by the oil pastels, filled in the area not covered by the initial drawing. The

work done in pastel therefore came through boldly.

So when you start off a picture, do not have too definite a view of the end product. If it is a drawing it might be advantageous to develop it into a watercolour or a pastel, or if it is a watercolour it can turn into an acrylic or, if you size over watercolour, into an oil painting. Similarly a drawing in oil pastel can turn into an oil painting. If this seems about to happen, you do not always need to size the paper, but let the oil paint soak into the surface. This results in a flat matt rather intriguing surface.

When you are working outdoors you have to be careful about how much equipment to take with you, but indoors there is a lot to be said for having *all* your painting equipment within easy reach. This can be a glorious muddle, and if you have a large table or working surface so much the better.

In picture making you have a number of

Salisbury Cathedral from the Meadows by John Constable. Places of architectural interest have long been a favourite subject for painters.

A typically adventurous painting by Turner in which the oil paint is used almost like watercolour, allowing the canvas to show through. This painting gives the impression of having been formed from accidental blotches and blobs of paint, though Turner was the last man to reveal the secrets of his techniques. choices. You can use pencil sketches made beforehand, or you can build up the painting as you go along, leaving some of it to chance. The 'blob' school of watercolour painters who included many good English watercolourists of the turn of the century laid down small splashes of colour and then meditated upon them until they could see an embryo picture – rather like looking at pictures in the fire. In some of his watercolour work J. M. W. Turner did much the same.

If you use preliminary sketches you can either reproduce them more or less exactly, or you can shift the subject around to make the picture hang together better – in other words making a composition of it. But there are certain subjects you may want to set down accurately. If you are doing a picture of your house you do not want to shift around the chimneys, alter the disposition of the rose bushes in the garden, or change the shapes of tree branches to make them look more artistic. You want a record, just as you do if you undertake a portrait. Similarly, if you are doing a well-loved landscape you do not want to move the elements around to make it pretty. You want it as it is, warts and all.

Remember that you are doing the picture for yourself. A visual autobiography can be enchanting to look back on, charting not only past events but your increase in expertise. If this is the reason you paint, nurture it – and *do not throw anything away!* Even if the picture does not quite come off, it may bring back memories. No one is going to give you a prize for a betterthan-average picture.

If the picture you are doing is imaginary, even if based on a real subject, you can include anything in it, including the improbable and impossible. Fantasy pictures are immense fun to do and may have some therapeutic benefit. If you know the rules, it is sometimes refreshing to forget them, and have different perspectives in the same picture, or even eliminate perspective altogether.

Reference has already been made to composition. This is something you can take into account or discard. At its simplest, composition

All the right ingredients are here to make a nice little drawing.

Here, the same ingredients are used in two dimensions.

Again, the same ingredients, but here they are used threedimensionally to make a satisfying composition. Two lively high-toned illustrations. Mediterranean scenes of this nature benefit from a fluid technique with the colour loosely applied.

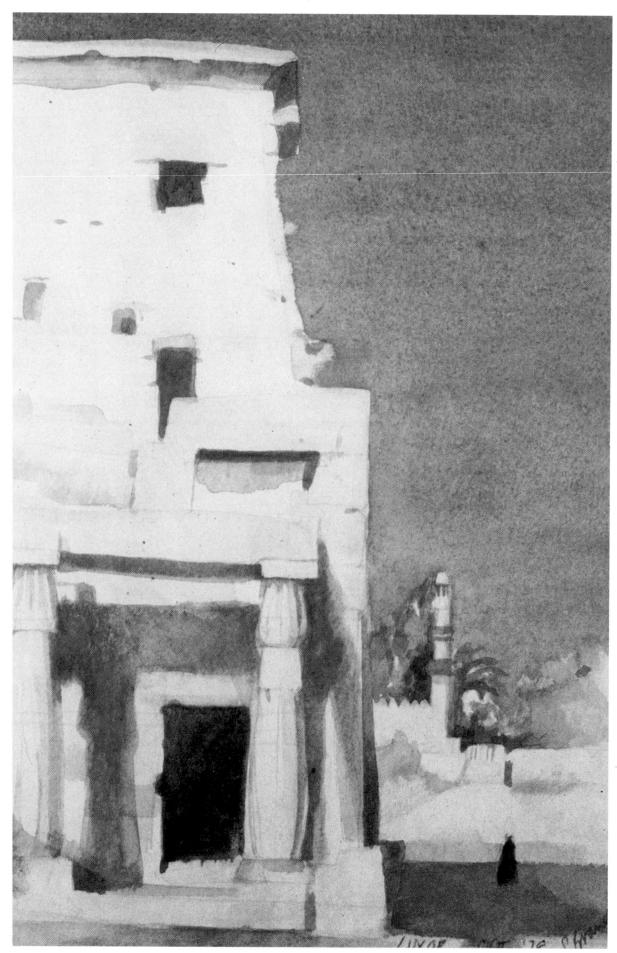

is making an interesting picture from a boring subject, and there is a good analogy in photography. Every photographic album contains architectural views – the White House, Empire State Building, or Stonehenge. How utterly boring most of these photographs are, the building set in the middle of the snap, nothing in the foreground except grass or a loved one. When we look at a professional's photograph of

the same subject, what a difference! The professional looks at angles, the light, foreground interest (and is concerned with keeping the camera still).

When you are sketching or painting on the spot it is sometimes difficult to decide which is the best vantage point (and sometimes you will not be able to get at the best vantage point because there is already something there such as an intrusive building). If you do not particularly want an exact visual record, then you can alter things when you get home.

The most important point about composition is to get the spectator to look into the picture and not across it, to focus on an area of interest, not necessarily in the centre. The part of the picture that attracts or pulls the eye towards it is sometimes known as an anchor. Degas often had his focal point at the extreme edge of the picture. If you can get the eye to come to rest on something in the picture so much the better. The most obvious way is to use perspective, the receding lines leading into the focal point, and in some way blocking them so that they do not lead out again. You can improve composition by raising or lowering the horizon, and you can use shadows to direct the attention. Foreground detail can also draw the viewer in, and if overloaded can keep the attention there - though it may be that this is what you want.

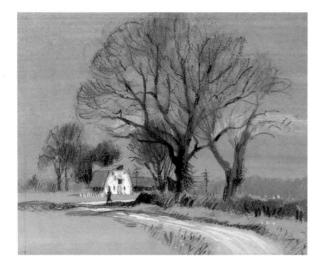

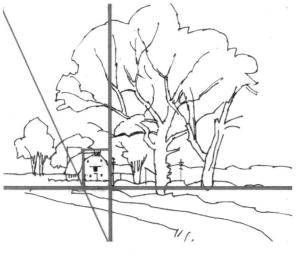

Composite drawings showing use of the Golden Section.

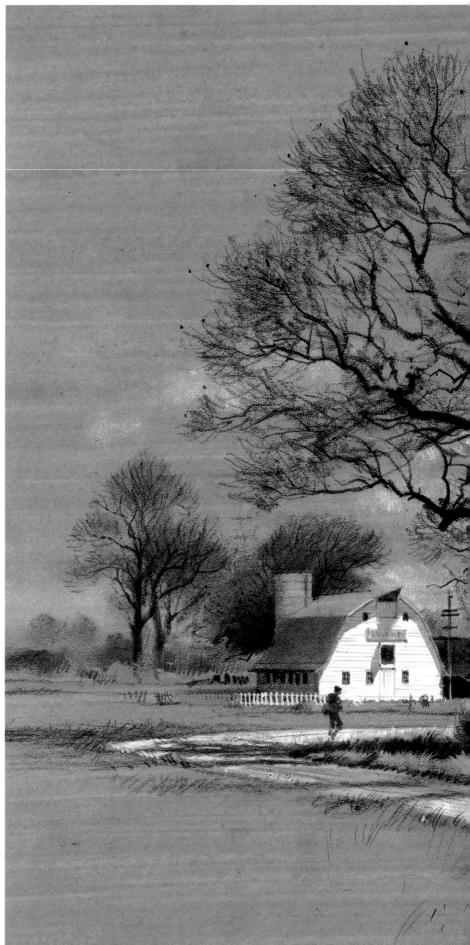

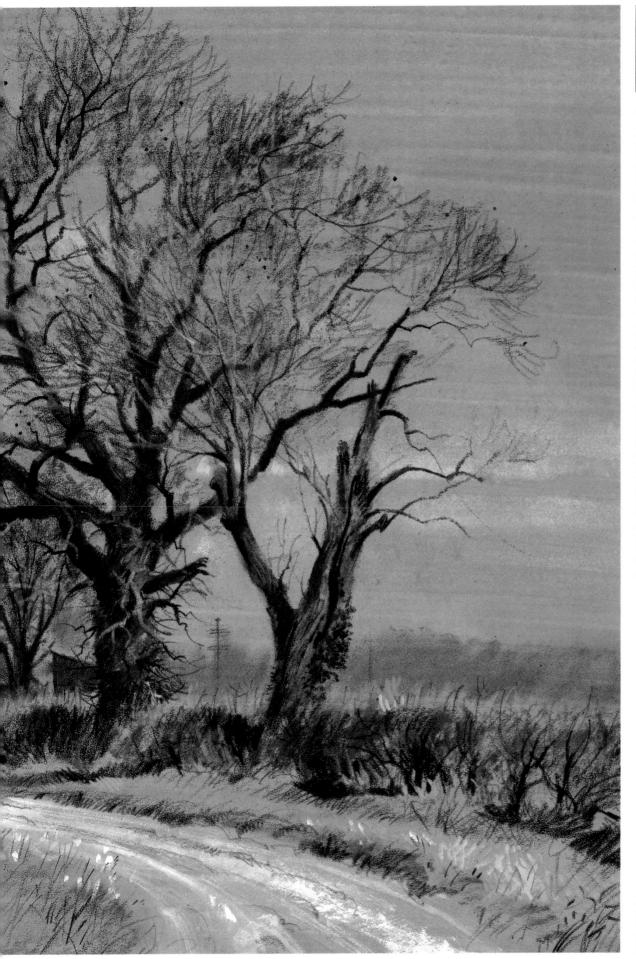

The Golden Section

Beauty can be a matter of mathematics as well as aesthetics, and something that is designed on mathematical principles will also look right. An example of this is the Golden Section, which the ancient Greeks used in the design of the Parthenon in Athens, and which is aesthetically very pleasing. It is a particular ratio between height and width, in the approximate proportion 13:8, though this cannot be expressed as an exact fraction. A rectangle constructed according to the Golden Section can be divided into a square and a smaller rectangle, and this smaller rectangle will have exactly the same proportions as the original one (see the diagram). Of course, this smaller rectangle can also be divided rectangle can also be divided into a square and a yet smaller rectangle of the same proportions, and so on for ever. The pattern obtained by joining corresponding points on the rectangles drawn by this division is exactly the same spiral as you see in seashells, which shows that the Golden Section can be found in nature as well as architecture.

In this charcoal drawing, on a grey-blue washed background, the artist has cleverly used a paint brush to highlight the road and barn.

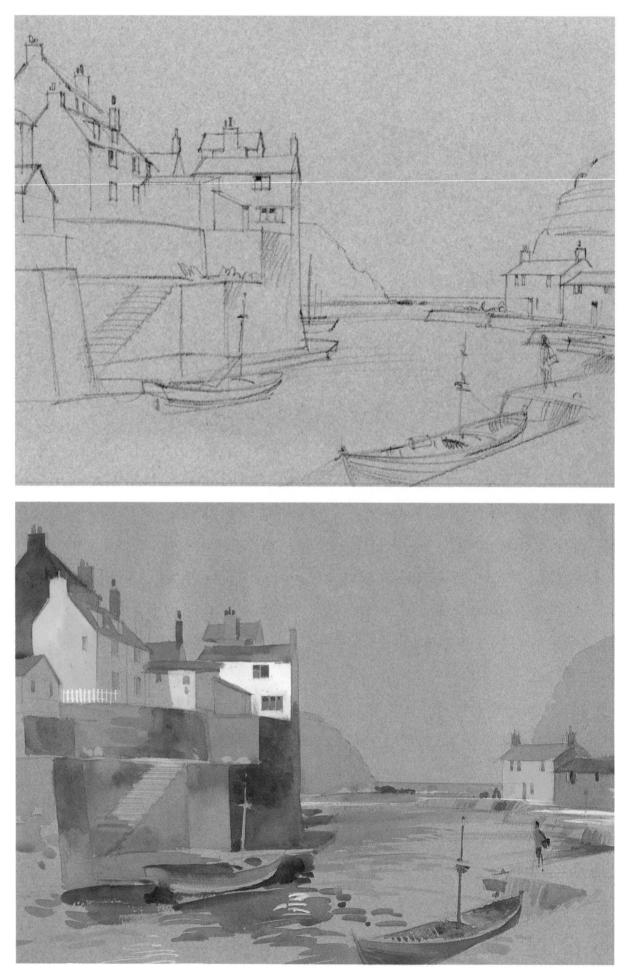

In the charming little seascape (*far right*) the artist has first of all quickly sketched in the areas he wishes to paint, over a blue-grey washed background. He has then simply blocked in the patches of colour and finally used a charcoal/Conté-type pencil to draw over the top to produce this pleasing effect.

In the old days there were reckoned to be golden rules of composition, and much time was spent by theorists in analysing the works of the great masters of the Renaissance to see how they behaved or how they fell short. To some of these self-styled experts, painting was geometry in action, and joy was unconfined when they found this or that painter using rules, especially when the subject of a wellknown picture was in the form of a triangle (in Virgin and Child pictures it would have been difficult to avoid). Even better when one triangle on its base was balanced by an inverted triangle, or there were intricate interrelated triangles to glorify.

It is probable that artists such as the 15thcentury Italian artist Piero della Francesca used a geometrical scaffold to base pictures on, and many artists, such as Hogarth, have published their ideas, though Hogarth does not seem to have acted on his theory of the 'curve of beauty'. There is therefore a lot of weighty theory about classical composition, and it can be satisfying to sketch in a geometrical figure and use it as the basis of a picture. But what is good composition to one can be boring to another. If composition can render a service, it is to stop the subject matter 'leaking' out of the edge of the picture.

One of the questions that arises if you are doing a watercolour (but not an oil) is whether to put in the outer limits of the picture when you start, in other words rule in a border. With a canvas you naturally cover the whole area. There are no hard and fast rules about a border; it helps some, hinders others, but if you are keen on composition and a balanced scheme then a border can be an asset. If you paint in a fantasy or formal style a decorated border can be an advantage - if it is carried out systematically. A geometric border which gets tedious because of the repetition and is skimped is worse than nothing at all. If the edges of a watercolour are getting ragged and inconclusive remember that you can always hide them under a mount – or cut them off.

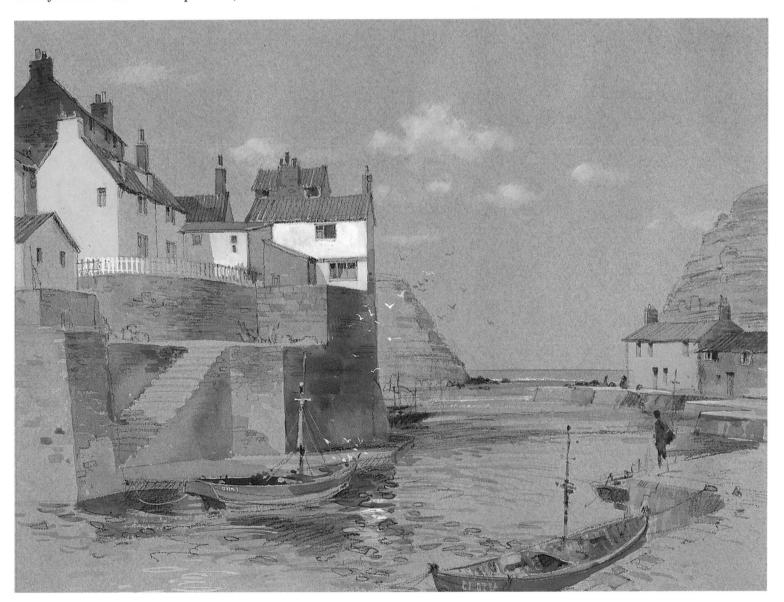

The fifteenth-century artist Piero della Francesca based most of his compositions on geometrical principles, as in his Madonna and Child (1) and *The Flagellation of Christ* (2). In stark contrast to the medieval beauty of Piero della Francesca is de Chirico, whose fantasized paintings (3 and 4) demand natural inquiry and attention to hold the viewer. He totally abuses the laws of perspective in order to distort one's senses. Salvador Dali's amazing skills and draughtsmanship in his paintings, such as Christ of StJohn of the Cross (5), can produce the magical uniqueness that should be the aspiration of any artist, whether exploring simple drawing techniques or as in the advanced classicism of the Virgin and Child in the frontispiece

If you are embarking on a fantasy or surrealist picture in the style of Dali or Chirico, try and keep to the same technique throughout. You can mix your mediums, but a medley of styles in the same picture never really works. It can be great fun working in someone else's style, doing a pastiche.

You must not feel you are being curtailed, and that certain techniques are artistically out of bounds. Not everyone has the egotism of certain famous painters who feel that even their thumb print is of value to someone. There are still numbers of techniques waiting to be found: so far as I know, nobody has yet experimented with painting on polystyrene ceiling tiles.

If you are one of those people who embark on a project with a set idea and are reluctant to be diverted from your path, you may think it trivial to doodle or to let the painting take over. A bit of doodling, if you happen to be a name, can be worth a fortune.

On 23 March 1983 there was a sale of modern and Impressionist art at Sotheby's, London. One of the pictures on show was *Nocturne* by the Spanish painter Joan Miro. The estimate was $\pounds 150,000 - \pounds 200,000$, and in the event it made $\pounds 270,000$ (about \$500,000). This is how Miro himself – a charming artist with a rich vein of invention – described the origin of the painting, in 1940-41:

'After my work (on oil paintings) I dipped my brushes in petrol and wiped them on the white sheets of paper from the album with no preconceived ideas. The blotchy surface put me in a good mood and provoked the birth of forms, human figures, animals, stars, the sky, and the moon and the sun. ... Once I had managed to obtain a plastic equilibrium and

Human and animal figures can be drawn realistically using a variety of techniques, and sometimes, through caricature and cartoon, humorously. bring order among all these elements, I began to paint in gouache, with the minute detail of a craftsman and a primitive.'

So when you have conquered the art of drawing to the best of your ability, or have decided that you have mastered it sufficiently to go on from there, there is a whole world of adventure and colour waiting for you. You may find that drawing is so fascinating in itself that that is sufficient, and you decide to pursue it, perhaps going into cartooning and caricature, the art of exaggeration and compression. It is up to you. But the ability to put something on paper which is not an aimless doodle is priceless, and easily come by. As I said at the start of this book, it is like playing the piano – only easier.

FRAMING

A good drawing is worth framing, and the instant that it is framed and stuck on a wall it gains an added prestige. 'It must be good if it is worth framing', visitors will think. Professional framing can be expensive, and it is worthwhile shopping around as prices vary enormously. One framer may charge twice as much as someone else for exactly the same job. The most reasonable are those who do framing 'for the trade', and they will be the best qualified to decide what colour or size of mount is the best.

Framing kits are widely available, but it is much cheaper to resurrect secondhand frames, bought at junk shops, garage sales, jumble sales and boot fairs for very little money. If you are framing watercolours, and only watercolours, do not be tempted to buy dozens of frames without glass, for although glass is not expensive it will mean going to a hardware store to get it cut or cutting it yourself as odd pieces of glass that you have lying around will rarely fit the frames you have.

If you buy a secondhand frame, clean it thoroughly and if some of the moulding is missing be firm and get rid of the whole lot. When the frame is clean it can be sanded down and painted, varnished, or if pine or a light wood, treated with linseed oil or wax and burnished with a soft cloth.

When cleaning the glass use detergent or a glass-cleaning agent, and perhaps a scrubbing brush. Flymarks may need to be picked off with the blade of a knife. When washed and dried the glass should be placed on a sheet of white paper and examined to make certain that it is clean. There is nothing worse than putting a picture in a frame and then seeing a smudge on the glass.

The glass will have been kept in place by almost anything – pins, nails, drawing-pins, Scotch tape – and there is little point in trying to reuse these. All old nails, etc., need to be taken out; if any are left there is a danger of breaking the glass by forcing it against nails which have been left in or have broken off. Professional framers use a stapler which pushes slivers of flat metal into the frame with great force but, for the occasional frame, brads, (headless tacks), are as good.

Drawings are seen at their best if mounted, and the mount itself should be bigger rather than smaller. A tiny drawing which does not look very exciting by itself can be transformed by placing it in the centre of a mount very much larger than itself. The equipment needed for cutting a mount are a surface such as a piece of thick card or wood – not a drawing-board as the knife will bite into the surface and ruin it; a craft knife or a scalpel; a steel rule, preferably of the safety kind; an ordinary rule, preferably transparent, for measuring; and a medium pencil such as HB.

Mounting-board is not expensive and comes in large sizes. Cut the size you want to fit the frame reasonably accurately, though absolute precision is not necessary as the mountingboard will be held in place by the brads. Measure the drawing to be framed, top to bottom, side to side, remembering that there must be a little overlap to go inside the space cut in the mount, and then divide in two the difference between the measurements of the mount and those of the picture. Put in your lines so that you have a grid; the intersecting lines should overlap slightly as they are then easier to see when using the knife. When cutting the mount keep the finger tips away from the edge of the steel rule; the rule will stay rigid if you splay the fingers. Never use a wooden rule or straight edge in association with a knife as no matter how much care is taken the knife blade will bite into the wood.

Three or four medium strokes with the knife are better than one deep stroke, and have the 'showing' side of the mount uppermost, otherwise there will be 'drag' and little flecks of card will stick up. If the piece cut out is 'sticky' go over the corners where the trouble is likely to be. Try not to cut past the intersections, though it will not show when the picture is framed.

Lining – putting lines round the aperture where the picture is to be – should be done carefully, and if not well done should not be done at all. If there is a risk of messing it up with a brush use a coloured pencil or pen and ink. The best kind of brush to use is the 'liner', made to do such work. Sometimes the spaces between the lines are colour-washed. Mounts for drawings are traditionally light in colour, but it is all a matter of personal preference.

A well-mounted drawing is sometimes spoiled by the addition of a picture title on the mount. A good artist need not necessarily be a good calligrapher. Or the wording might be ill-balanced, not lined-up, or on a slant. Use a ruler to set in the proportions of the letters, work out how long the words are, put them in lightly in pencil, and if you are not experienced do not use fancy lettering. A very good substitute for handlettering is Letraset. But a drawing need not necessarily have a title. It is a good idea to look at drawings and watercolours in galleries to see how they are framed, mounted, and entitled; even if the pictures in commercial galleries are uninteresting the owners know that good presentation can help enormously in selling them.